DISCOVERING
Watercolor

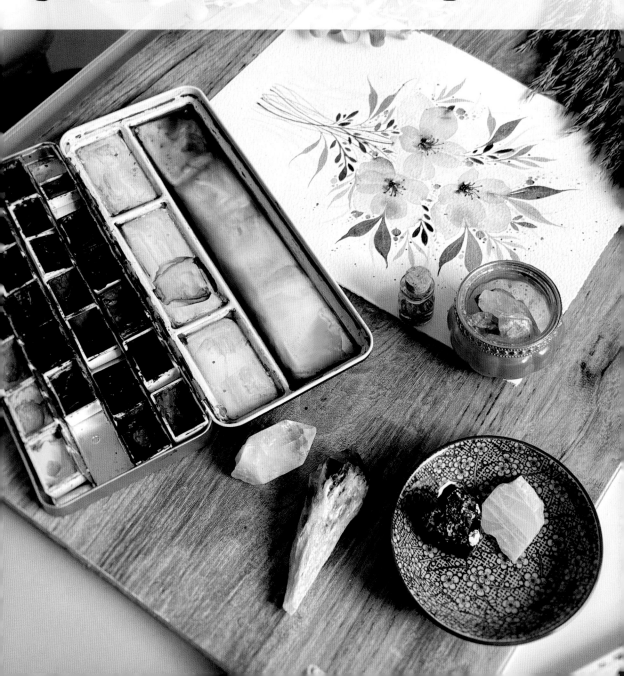

J'ose l'aquarelle
Copyright © 2021, Éditions Eyrolles, Paris, France

ISBN 978-1-4972-0652-6
Library of Congress Control Number: 2023937525

Cover art is a recreated design inspired by the photography of Eric Niven.

To learn more about the other great books from Fox Chapel Publishing, or to find a retailer near you, call toll-free 800-457-9112
or visit us at *www.FoxChapelPublishing.com*.

We are always looking for talented authors. To submit an idea, please send a brief inquiry to
acquisitions@foxchapelpublishing.com.

Printed in China
First printing

DISCOVERING
Watercolor

An Inspirational Guide with Techniques and 32 Skill-Building Projects and Exercises

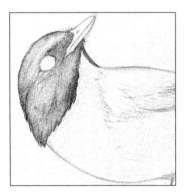 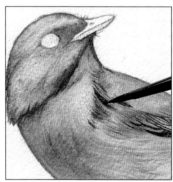 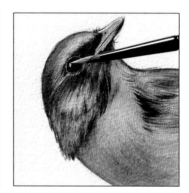

Jennifer Lefèvre

DESIGN ORIGINALS
an Imprint of Fox Chapel Publishing
www.d-originals.com

CONTENTS

Introduction 7

- PART 1 -

GETTING STARTED

- PART 2 -

UNDERSTANDING COLOR

- PART 3 -

CREATING PLANT MOTIFS

- PART 4 -

CREATING A FLORAL COMPOSITION

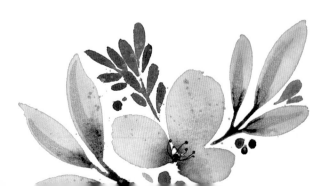

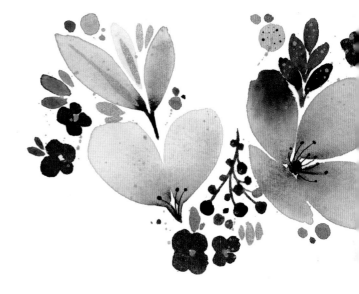

- PART 5 -

AN INTRODUCTION TO LANDSCAPES

- PART 6 -

REALISM WITH WATERCOLORS

- PART 7 -

DEVELOPING YOUR ARTWORK

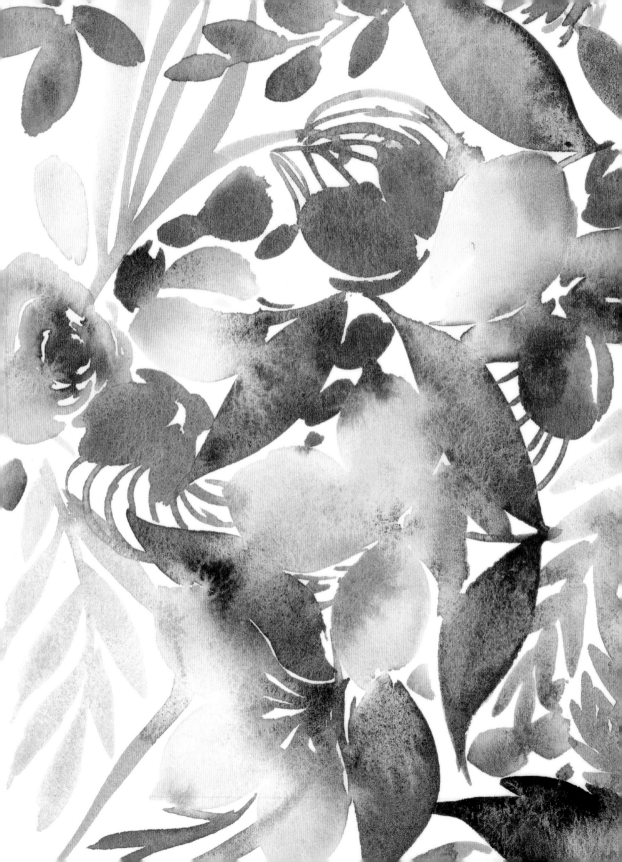

INTRODUCTION

I discovered watercolor painting at the end of 2017, and it was a revelation to me.

From realism to abstract, I'm constantly amazed by the infinite possibilities offered by this medium.

I let myself be carried away by the colors, the mixtures, and the unpredictable combinations. While the water guides me on my journey, I also guide it. I play with textures and blends. In short, as you'll no doubt have gathered by now, I never tire of working with watercolors and it's a source of great delight.

Every day, I discover talented artists on Instagram who transport me to new and unique worlds, while also reminding me how fascinating this medium is. I had the great pleasure of interviewing some of them about their creative processes while writing this book.

Through the 32 lessons presented in this book, I hope to share my passion for watercolors with you, as well as all the benefits they bring to my daily life. I hope you experience the pleasure of creating without pressure or constraint. I hope you explore and experiment to better understand yourself, your artwork, and your artistic preferences.

Finally, I also hope to introduce you to the many different ways of approaching this medium, which has only you and your creative spirit as its master.

GETTING STARTED

Selecting the tools that will support your watercolor painting is an essential step.

When I first started, I remember feeling both intimidated and fascinated by the huge array of products in art supply stores. The many different types of paper and brushes, and the wide range of colors offered by each brand, gave me a feeling I won't forget.

Although I already know my preferences, your choice of tools will depend on your tastes and artistic habits.

As a beginning point, we'll look at how to use the different tools you can find in specialized stores, and then how to put together a kit to help you get started with watercolors.

CHOOSING
YOUR EQUIPMENT

THIS IS THE FIRST LESSON ON YOUR ARTISTIC JOURNEY. PUTTING TOGETHER
A KIT SUITABLE FOR A BEGINNER WILL HELP YOU GAIN CONFIDENCE AS YOU
TAKE YOUR FIRST STEPS WITH THIS MEDIUM.
AS YOU EXPERIMENT, YOU'LL FINE-TUNE YOUR CHOICE OF TOOLS AND ADAPT
THEM TO YOUR NEEDS.

The essentials

There are a few tools that are essential for working with this medium.

- Brushes specifically designed for watercolors, which have the ability to absorb water thanks to their fibers and bristles. I recommend buying four brushes: two soft, round brushes in small and medium sizes to vary the shape of your brush strokes; a finer, stiffer brush for more precise strokes; and a flat brush, which is very useful for depositing a large amount of water or paint in one place on your painting

- 300 gsm watercolor paper is specifically designed to handle more than one application of water. The two most well-known ranges are:

 - Cellulose, an entry-level paper that's very good for beginners, as it's not very expensive. I still use it to this day for experimenting and practicing.

 - Cotton paper, which is more expensive because it's of much higher quality. It allows for better watercolor blending and results.

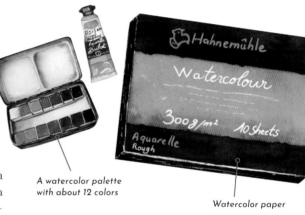

A watercolor palette
with about 12 colors

Watercolor paper

A watercolor brush

To get started with watercolors, you'll need three essential tools.

- A palette of fine or extra fine watercolors containing at least 12 pans for experimenting with different blends. Fine watercolor paint has a lower concentration of pigments, but still gives beautiful results and is ideal for beginners, as it has a much more affordable price.

- A water bowl, as this is one of the most essential ingredients in watercolor painting.

- A cloth, to absorb excess water from the brush.

Properties of watercolor paints

The labels on your watercolor tubes or pans contain small pictograms providing information about the paint's various properties. These symbols will differ slightly from brand to brand, but they all represent the same things.

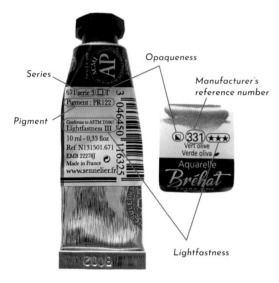

Series

Opaqueness

Manufacturer's reference number

Pigment

Lightfastness

- **Opaqueness and transparency**

Four different squares indicate the transparency level of each color, and therefore its covering power. The different levels are indicated by the following symbols:

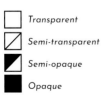

Transparent

Semi-transparent

Semi-opaque

Opaque

- **Color permanence (AA, A, and B)**

"AA" means that the colors will retain their intensity over many years, whereas the letter B indicates less permanence, and the letter A is in-between.

- **Series**

The series number on your tube or pan, sometimes represented by the letter S, is followed by a number from 1 to 5. It refers to the price of the pigment used to make the color.

For example, S5 represents a very expensive pigment and S1 a less expensive pigment. As a result, the price of your tube or pan will vary primarily based on this information.

- **Lightfastness**

The stars ★★★ the +++ or the indication "ll" or "l", depending on the brand, determine your watercolor's level of lightfastness (its resistance to fading) over time. For example, one star indicates low lightfastness, while three stars means very high lightfastness.

- **Staining properties**

This measures the color's adhesion to the paper. Colors labeled "ST" (meaning "staining") will not move or will move very little once placed on the paper.

- **Pigment**

The name of the pigment(s) used to create the color is shown on the various containers. For example, the pigment PR122, which is shown here, is listed as a quinacridone pink/magenta in the Color Index (classifying the various pigments). With Sennelier paints, this is the color "Helios Purple," with manufacturer's reference number 671. In PR122, the "P" stands for pigment, the "R" for red and 122 for the color shade. This color clas-

sification is universal and is also used for other mediums, such as gouache, acrylic, oil, pastels, and colored pencils.

- **Manufacturer's reference number**

Each manufacturer assigns a code to their color, making it easier for painters to find it in their product range.

- **Granulation**

Some watercolor containers are marked with a "G" to indicate granular paint (see lesson 2).

- **Fine or extra-fine**

The main difference between extra-fine and fine watercolors is the quality and quantity of pigments contained in them. Extra-fine watercolors will give a better finish and will last longer over time. The quality of the binders can also vary between these two ranges. Binders are used to bind the pigments together and give the paint good consistency. For example, extra-fine watercolors most often contain gum arabic, while fine watercolors more commonly contain dextrin, a less expensive binder.

For a better understanding of how watercolors are made, I encourage you to read Valentine and Florence's story on page 33. They are the creators of Les Couleurs VF, a brand that specializes in handmade watercolors.

Different types of containers

You can buy watercolors in two types of packaging: tubes and pans. Depending on how you want to use them, you may prefer one or the other.

Tubes

Some artists prefer to put the paint directly onto their palette, as this results in a more concentrated pigment and more generous quantity. The paint, therefore, is creamy, making it possible to work on larger formats without needing to reactivate it with water.

For my painting, I use a handmade ceramic palette made by Sarah Diane (Sylvan Clayworks). I like to use it in conjunction with tubes of color that I don't have in my palette, or that don't reactivate well from the dry pan form. Sometimes, I just like to expand the mixing areas to explore more color combinations, as the four wells in my metal box are not big enough. I urge you to read Sarah Diane's story (see page 20) about designing handmade ceramic palettes for artists.

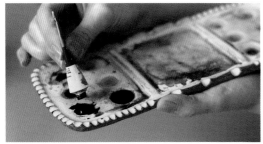

Ceramic palette made by Sarah Diane.

You can also fill your pans with paint from tubes. For example, if you use one particular color a lot, it may be a good idea to buy it in a tube so you can better predict when your pan will run out and manage your paint inventory. In addition, tubes are generally more economical in terms of price per fluid ounce. For example, a 0.5 fl. oz. tube will fill about six half-pans. On a final note, I find tubes much easier to organize than pans, which is a big plus for me on a day-to-day basis, as I know at a glance exactly what I have.

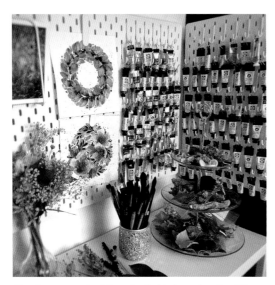

Here is an example of the setup behind me when I'm sitting at my desk painting (you'll notice my little color collection in the corner).

Pans

Watercolor pans come in solid form in small plastic containers. Pans are easier to carry around and are very popular with outdoor painters (see Sarah Van der Linden's account of her nomadic style of watercolor painting, page 78).

However, the paint needs to be reactivated with a little water before use, particularly in the case of handmade watercolors.

Handmade watercolors made by Les Couleurs VF.

Ready-to-use palettes provide a good base for getting started with watercolors. They contain a variety of colors, carefully selected by the brands, allowing you to explore a variety of different blends (see lesson 4).

Brushes

There are brushes of various shapes and sizes on the market, made either of natural hair or synthetic fibers. This allows us to vary the visual effects we can achieve in our paintings.

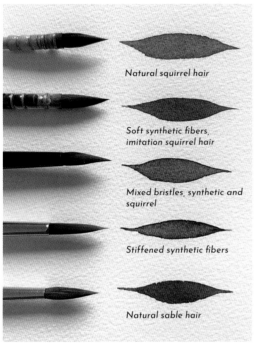

Natural squirrel hair

Soft synthetic fibers, imitation squirrel hair

Mixed bristles, synthetic and squirrel

Stiffened synthetic fibers

Natural sable hair

A selection of round brushes

Natural hair

The most common natural hair used for watercolor brushes is sable and squirrel.

The squirrel-hair brushes are cheaper than sable-hair brushes. They are very supple and retain water well. They allow you to create large, natural shapes. However, they can be difficult to handle for beginners, as their lack of stiffness can sometimes be unsettling.

Sable brushes are the ultimate in quality brushes. They are well-balanced between suppleness and stiffness. Sable hair retains water well and regains its shape after passing over the paper, so it's easier to be precise with these brushes.

Synthetic fibers

The range of synthetic fiber brushes is very wide. Some fibers are very stiff and produce a fine and precise result. Others are softer and designed to imitate natural hair. In general, synthetic fibers tend to wear out faster, but are less expensive than natural fibers.

Brushes made from a mix of natural and synthetic fibers offer a good balance between price and quality. For beginners, I recommend using synthetic fiber brushes that are imitation squirrel hair, as they're less expensive and excellent for painting all kinds of motifs, given they're a bit stiffer than natural-hair brushes.

Special shapes

There are many different shaped brushes on the market. It's worthwhile daring to vary your brush shape, particularly for landscapes, in order to add texture to your paintings. For example, a small, flat, tapered brush is a great choice for creating the effect of grass, animal hair, etc.

I advise you to buy at least one flat brush, about 0.8" wide, which is very useful for covering large areas with water or paint. You should also have three round brushes made of synthetic fibers: a small, precise brush; a large, soft brush; and a third, stiffer brush for more precise brushstrokes.

For my artwork, I use round brushes most of the time. I occasionally use flat brushes to cover large areas.

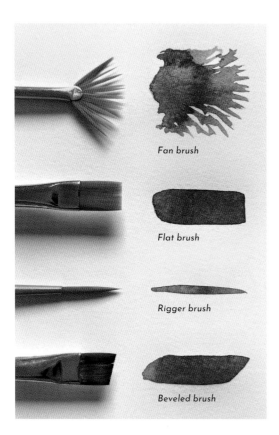

Fan brush

Flat brush

Rigger brush

Beveled brush

Please note Selecting your brushes is a very personal choice. Apart from your budget and artistic style, you will find differences in the way you feel when handling them. Your preferences may change as you gain more experience.

Brush maintenance

To make your brushes last as long as possible, I suggest rinsing them with clean water after each use and reshaping their tips. I usually dry my brushes vertically and head down, and then store them in my brush jar when they are dry. Take care never to leave your brush in the water pot, as this can distort the tip. Also, be aware that there are special soaps available designed to care for your brushes.

Paper

There are several papers that can be used for watercolor painting. Here's a short introduction to the two most common types.

Cellulose paper

This type of inexpensive paper allows you to explore all the different ways watercolors can be used. However, it has a smoother surface than cotton paper, which may hinder proper pigment adhesion. As a result, little halos are often formed due to irregular drying, and transparency is more difficult to achieve. Cellulose paper also dries faster than cotton paper. Blending (see lesson 5) is good, but not as high-quality as on cotton paper.

In my early days, I experimented a lot with watercolors on Hahnemühle's "Le Rouge" watercolor paper from their Moulin du Coq range, in 325 gsm fine grain. I was learning the skills and the low cost of the paper allowed me to try many different subjects. Now that I'm more comfortable with the medium, I prefer to paint on cotton paper, but I keep some cellulose paper on hand for further research and experimentation.

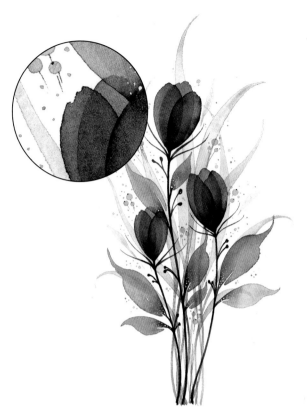

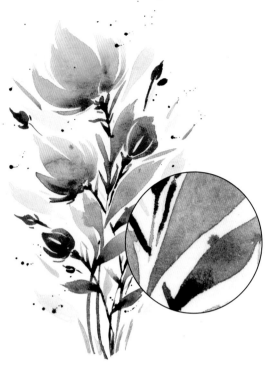

Watercolor painted on cotton paper

Watercolor painted on cellulose paper

Cotton paper

More expensive but also higher quality than cellulose paper, it allows for excellent color blending and better contrasts. Because of its rougher surface, the paint adheres more easily and retains its color better. Water evaporates more slowly, enabling you to spend more time working wet-on-wet. As I grew in skill and confidence, I gradually replaced cellulose paper with cotton paper. Depending on the type of watercolor design I want to paint, I will use different types of cotton paper. Sometimes, I prefer to work with very textured, handmade papers to play with granulation (see lesson 2), other times I prefer a smoother finish, when painting portraits, for example (see lesson 26). More than anything, it's a matter of taste.

On cellulose paper, we can see where the paint has dried a little unevenly and the blending isn't as good.

On cotton paper, the colors are perfectly blended.

Different grains

As well as the type of paper, its grain should also be considered. There are three kinds, which are more or less textured, depending on the brand.

- Satin finish is very smooth in appearance and water is absorbed more quickly.

- The torchon grain, also called "rough," is very textured and the watercolors dry slowly. It's therefore best-suited for working for long periods wet-on-wet.

- Fine grain is in-between torchon grain and satin finish. It's a popular choice of paper because it's so versatile. It dries faster than torchon grain, but slower than satin finish.

Fine grain paper in 300 gsm is a good one to start with because of its versatility. It also allows you to get used to the special textural aspect of the paper. This grain is still my favorite, but you can gradually explore using watercolors on more textured papers, in order to try different granulation effects (see lesson 2). The most textured paper I've tried so far is Shizen Paper. It dries very slowly, so it makes blending much easier (see lesson 5).

The thicker the paper, the less it distorts when in contact with water. For this reason, I recommended that you paint on watercolor paper of about 300 gsm, which greatly reduces this distortion. The highest weight I've seen is 850 gsm. However, there are watercolor notebooks with a weight of less than 300 gsm (230 gsm), which are quite water resistant, but tend to curl. To avoid this drawback, you can fasten the pages together with a clip. It's also possible to fix the sheet on your workbench by putting masking tape on all four sides to hold it in place, particularly if it gets very wet.

Below is the Moonglow color by Daniel Smith, which has a granulation effect and allows us to get a better idea of the different types of paper grain. The three papers shown are from Hahnemühle's Watercolor range in 300 gsm. From left to right: satin finish, fine grain, torchon grain.

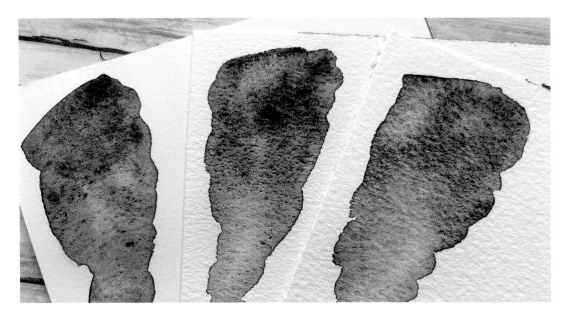

Masking

When using watercolors, different tools will allow you to preserve the whiteness of your paper, which is particularly useful when painting landscapes. It also allows you to, for example, have lighter elements against a dark background.

Masking fluid

This is a liquid gum that becomes rubbery when it dries, allowing you to paint over it. When the paint is dry, the fluid can be removed with an eraser or your fingertip, by rubbing it gently. Once removed, the white part of your paper is visible.

Masking fluid is particularly useful for creating small shapes on watercolor paper using a clean brush. It's best to use a lower quality brush, as the fluid tends to damage the bristles.

Masking tape

Masking tape is the same as that used when painting your home. It prevents paint from adhering to the area on which it's placed.

Unlike masking fluid, tape can't be used to create small, precise shapes, so it's more useful as a framing tool; for example, marking out the area where you want to do your watercolor painting.

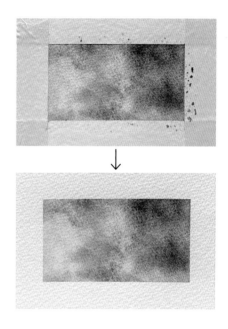

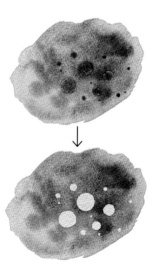

Once your painting is dry, remove the masking fluid to reveal the blank areas on the paper.

GIVE IT A TRY

Browse around an art supply store to familiarize yourself with the different products available and put together a basic kit that will enable you to start painting.

Watercolor paints
Get yourself a palette with about 12 different colors. Go for fine watercolors that provide good pigmentation without being too expensive. This type of palette is very easy to use.

Brushes
Choose two round brushes, the first one thin and precise, the second one thicker and more supple for larger, more variable shapes. Round brushes are very versatile and will allow you to paint a lot of different shapes. Supplement as needed with a flat brush and one that's stiffer.

Paper
Although cotton paper is more expensive than cellulose paper, I recommend buying a 300 gsm pad of each type so that you can get a better idea of how to use both.

DIVERSIFYING YOUR ACTIVITIES

SARAH DIANE

Tell me a bit about yourself.

My name is Sarah Diane and I'm the founder, designer, artisan, and anything else required, behind Sylvan Clayworks.

I'm based at The Clay Lady's Campus in Nashville, Tennessee. I handcraft high-quality ceramic palettes and accessories, along with the occasional other piece. All of the ceramic artist's tools that I make are small-batch, slab-built and crafted with care. My mission is to create innovative, handmade ceramic products that will enhance any studio, table, or home.

I'm a motivated and versatile artist who loves people intensely and hates being the center of attention. I like to encourage others and inspire them to achieve their dreams. I also strongly believe that it's everyone's responsibility to take care of the Earth in any way we can. Protecting the environment is one of my core values. As an e-commerce business, the best way for us to be involved in saving our planet is through our packaging. All my packaging is environmentally friendly and sustainable: biodegradable cornstarch fillings, recyclable paper, and recyclable boxes sealed with biodegradable paper tape.

How did you become a ceramic artist and what led you to begin designing palettes for artists?

I fell in love with clay when I was 15 years old. I just knew that pottery was for me. I took every pottery class I could in high school and eventually earned my BFA in ceramics from the Tyler School of Art at Temple University. After graduating, it took me a while to find my niche within my medium, all the while doing other work like au pairing and waitressing. Throughout those seven years, I never lost my passion for ceramics and creativity. I taught classes, sold a few pieces and was even commissioned to make the dishes for the Treehouse Restaurant here in Nashville. Finally, a group of friends gave me a website for a year as a Christmas gift. At the time, I had no money to invest in my business and no reliable way to sell my pieces.

This incredible gift helped me develop my business and online platform, which has proven essential in building relationships with other artists around the world. I still remember my first order from a real customer. It was awesome! This gave me the confidence to pursue my artistic career in a more professional way.

Over the next four years, my work changed dramatically, with varying degrees of success. I was mainly doing functional pieces using a sgraffito technique. Then in 2018, I collaborated with a good friend, Shealeen Louise, who is popular on social media. After working with her to create beautiful watercolor illustrations, I was inspired to make ceramic palettes. I was surprised to discover that there were none on the market, so I made a few.

Even after achieving this modest early success, it wasn't easy. I doubted myself, as my sales were barely covering the cost of my studio, let alone my

rent. I often thought about hanging up my apron and quitting. But I knew that if I did, I would regret it for the rest of my life. It took an incredible amount of faith, and I'm so glad I had it.

I'm really proud to report that my platform now features the world's first collection of handmade ceramic palettes.

What are the challenges of your profession?

As a successful but very small business, I have many. But they're only minor problems. Ensuring that shipping costs and turnaround times are low, handling paperwork, managing production and kiln space limitations, etc. Also, as any ceramicist knows, there is always a risk of failure when working with clay.

I struggle the most with tax and legal issues. If you're a young artist looking to start your own business, I recommend that you find an accountant you can trust!

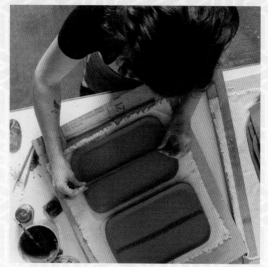

Sarah Diane creating a ceramic palette.

What inspires you?

Simple shapes. I love the Bauhaus school and brutalism, as well as mid-century modern furniture and raw textures. Mies van der Rohe, Le Corbusier, Niemeyer, etc. I'm planning to start a personal series soon focusing on clay bodies, raw texture, and muted natural colors.

Can you tell me a bit about your creative process?

When it comes to my palettes, I always try to let the function determine the form. They are all created with artists' practices in mind, making the utility elegant. I want to create things that are both aesthetic and useful for those who create beauty. Lately, I've had the chance to experiment with different kinds of clay and techniques, and I'm very excited to be starting a new body of work apart from palettes. In my personal work, I decided that I needed to devote more time to experimenting. I'm going to set aside one afternoon a week to have fun with the clay and get my curiosity back.

Instagram: @sylvanclayworks
Website: sylvanclayworks.com

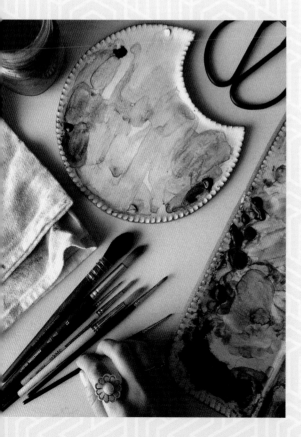

LESSON 2

PLAYING
WITH TEXTURES

**AS A GENERAL RULE, WATERCOLORS ARE FAIRLY UNIFORM IN
APPEARANCE WHEN DRY. HOWEVER, SOME PIGMENTS CREATE
GRANULARITY IN THE PAINT AND THUS CREATE SURPRISING
TEXTURAL EFFECTS IN WATERCOLOR PAINTINGS.**

New perspectives

This subject is very close to my heart, as I'm fascinated by the artistic perspectives offered by granulating colors. I wasn't immediately attracted by these effects, but as time went by, I realized it was possible to achieve visual effects that would arouse curiosity and attract the eye by subtly adjusting how I used them.

Demonstrating that this result is intended and crafted, that it's neither an error, nor a defect in the color's design, lies all the artistic interest that I strive for when using highly granulating watercolors.

Pigment granulation

Pigments, whether natural or artificial, are the coloring agent in the paint. They can be vegetable, mineral, or synthetic in origin. Most granulating pigments are obtained from minerals, i.e., oxides, metals, stones, soils, etc.

Some pigments are heavy and will clump together on the textured parts of the watercolor paper—we call this "flocculation."

Different granulation effects occur with chromium, iron, titanium, zinc, cobalt, and magnesium oxides. The Goethite Yellow Ocher from the manufacturer Daniel Smith, for example, contains the pigment PY43, which is a natural iron oxide. Cobalt Green from Winsor & Newton contains the pigment PG50—a cobalt-titanium oxide.

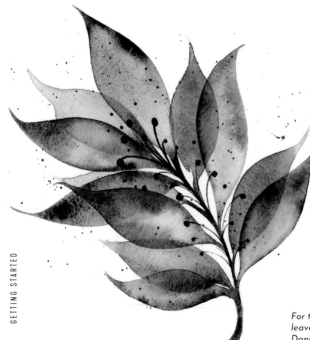

For this small leaf motif, I had fun adding texture to my leaves using granulating watercolors.
Daniel Smith's Goethite (left), Winsor & Newton's Cobalt Green (right).

Daniel Smith's Goethite (left), Winsor & Newton's Cobalt Green (right).

The Moon Black color from Daniel Smith, for example, gives the impression that the pigments are attracting and repelling each other like small magnets. This is the effect we get from the pigment PBk11—a black iron oxide.

Likewise, the Moon Earth color from the same manufacturer produces a similar effect, this time due to the PBr11 pigment, which is magnesium ferrite.

TIP The more you play with water on a very textured paper—i.e., torchon paper—the more granulation will occur.

Salt effects

Other textural effects can be created by adding salt to wet watercolors, which has the effect of displacing the pigments in a surprisingly random way. The more water there is on the paper, the more pronounced and unpredictable the effect.

Here, I had fun creating a galaxy effect in each of my circles using Paynes Gray, Helios Purple, English Green, and Ultramarine Blue from the Bréhat range. The only difference between the two paintings is that I added salt to the one on the right when it was still very wet.

Watercolors without salt (left) and with salt (right).

Daniel Smith's Moon Black (left) and Moon Earth (right).

GIVE IT A TRY

Experiment with adding salt to your watercolors.

1. Use a sheet of textured paper and arrange dark colored pigments all over it so you can clearly see the effects of the salt.

2. Spread a little salt on the still wet paint. As it dries, you will notice that the paint will be displaced in the areas where the salt has settled.

You can experiment by adding salt at various points in the drying process to see the different results.

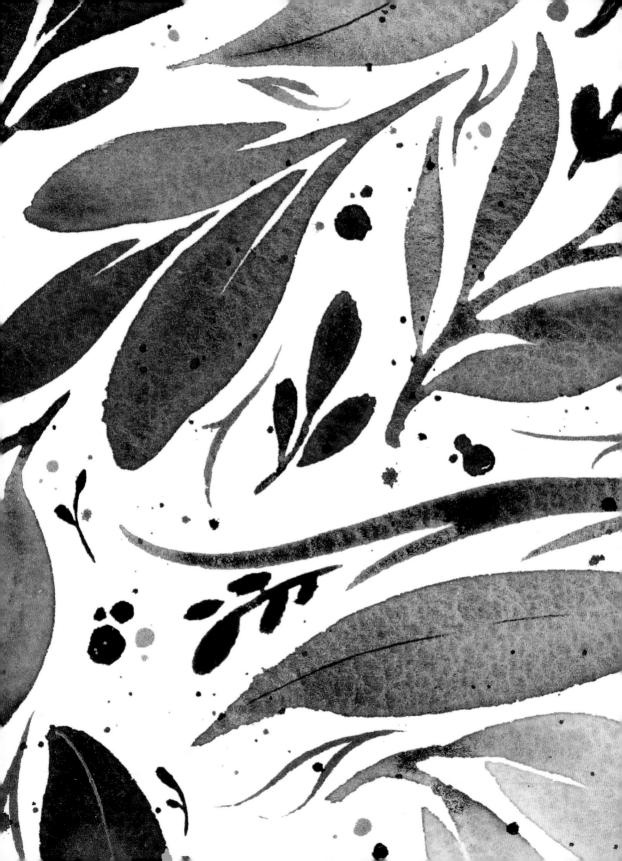

UNDERSTANDING
COLOR

Before learning to master shapes and technique, it's essential that you understand color balance. What I like most about watercolors is their unpredictability and the element of surprise in the end result. The pigments move, mix, blend, and sometimes create unexpected pairings. Colors generate emotions, create signatures, tell stories... Some combinations can spark our creativity because, even before we learn how to produce motifs, we can create eye-catching color effects.

Here, we will discuss some ways in which you can use your palette to its fullest potential. I will give you tips on how to create original combinations that you will develop into a research notebook, and how to add intensity and beautiful contrasts to them.

LESSON 3

CREATING
A COLOR CHART

CREATING A COLOR CHART IS NOT ONLY USEFUL FOR VISUALIZING YOUR
COLORS, BUT ALSO FOR UNDERSTANDING EACH COLOR'S UNIQUE FEATURES.
INDEED, SOME ARE MORE OPAQUE AND OTHERS MORE TRANSPARENT. SOME
ARE MORE GRANULAR, WHILE OTHERS ARE SMOOTHER AND MORE UNIFORM.

Warm and cool colors

Balancing warm and cool is primarily a matter of
perception and feeling. To help you better visualize
this concept, I made a color wheel using three pri-
mary colors I have in my watercolor palette. I chose
Light Yellow, Dark Ultramarine Blue, and French
Vermilion Red from the Bréhat range.

TIP You can make a color wheel using any
type of blue, red, or yellow.

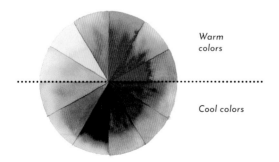

Warm
colors

Cool colors

If we cut the color wheel in two, on one side we
can see the warmer colors, and on the other side the
cooler colors.

TIP Making a color wheel is an important ex-
ercise, as it reminds us of the basics of mix-
ing primary, secondary, and tertiary colors. For
example, primary colors can't be produced by
mixing.

Classifying colors

I've gotten into the habit of sorting my colors by
tone, from warmest to coolest (see lesson 4). It's a
way to better find my way around my palette, espe-
cially since it has grown over the years. However, this
is still a matter of perception, so you can adjust yours
according to your preferences. Making a color chart
for my palette also allows me to catalog the colors I
have. I write the name and brand under each color so
I can refresh it if needed. It also helps me to quickly
visualize the color's appearance on the paper and to
make better color choices for my paintings.

UNDERSTANDING COLOR

I like to arrange the colors in gradients in my color charts because I can then quickly see the color in both its most concentrated and its most diluted forms.

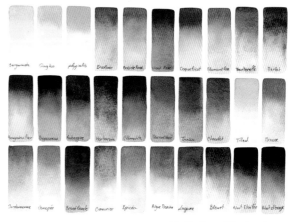

My Couleurs VF color chart.

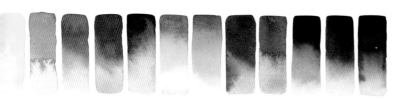

Colors from left to right: Light Yellow, Quinacridone Gold, French Vermilion Red, Helios Purple, Dioxazine Purple, Dark English Green, Hooker Green, Van Dyck Brown, Dark Ultramarine Blue, Prussian Blue, Paynes Gray, Neutral Tint.

1.

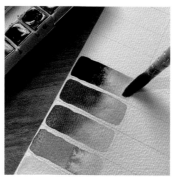

2.

3.

4.

Step-by-step

To make this color chart, I used a watercolor palette of 12 extra fine colors from the Bréhat range by Dalbe.

1. On a sheet of watercolor paper placed horizontally, draw as many 1" x 2" boxes as there are colors in your palette.

2. Apply highly concentrated pigment color to a quarter of the box's area.

3. Rinse your brush and load it with just water.

4. Gradually defuse the color until you reach the bottom of the box.

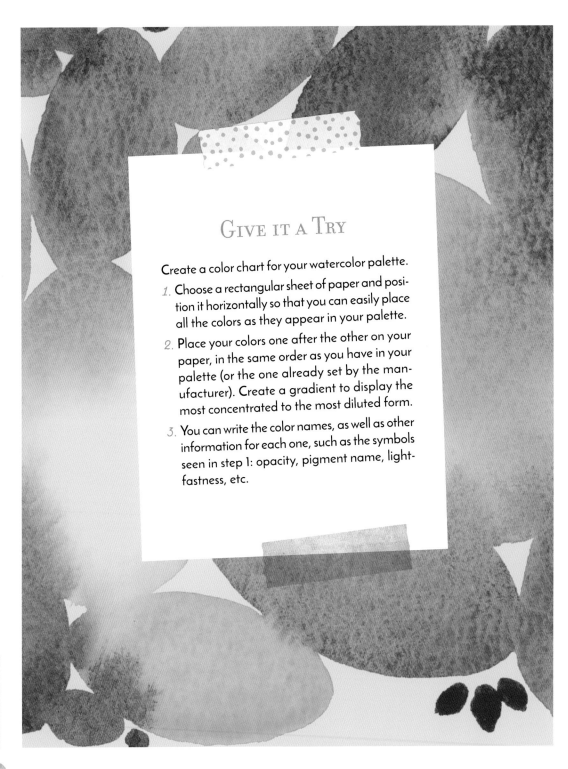

GIVE IT A TRY

Create a color chart for your watercolor palette.

1. Choose a rectangular sheet of paper and position it horizontally so that you can easily place all the colors as they appear in your palette.

2. Place your colors one after the other on your paper, in the same order as you have in your palette (or the one already set by the manufacturer). Create a gradient to display the most concentrated to the most diluted form.

3. You can write the color names, as well as other information for each one, such as the symbols seen in step 1: opacity, pigment name, lightfastness, etc.

KEEPING A
BLENDING LOG

KEEPING A LOGBOOK WILL HELP YOU ORGANIZE YOUR COLOR
COMBINATION IDEAS AND KEEP TRACK OF THE BLENDS YOU LIKE BEST.
YOU'LL ALSO BE ABLE TO SEE HOW YOUR RESEARCH IS PROGRESSING—
LIKE A DIARY—AS WELL AS TAKING OWNERSHIP OF YOUR PALETTE AND
ADAPTING IT TO THE COLORS THAT RESONATE WITH YOU THE MOST.

Understanding your preferences

As I compiled my blending log, I realized that I was
drawn more to colors with natural tones, especially
greens, reds, earth tones, ochers, and oxides.

When I explore new palettes, I have fun blend-
ing opaque colors with transparent ones, uniform
colors with granulating ones, and warm tones with
cool ones (see lesson 3). I log my research in an A5
landscape notebook from Etchr Lab. It is a 100%
cotton notebook with a fine grain of 230 gsm.

There are no unbalanced color palettes, as long
as the colors have been carefully selected based on
the interplay of contrasts (see lesson 6).

As you experiment, you will eventually find color
combinations that you're particularly fond of. In les-
son 7, I will show you some of the techniques I use to
develop original and unique color palettes.

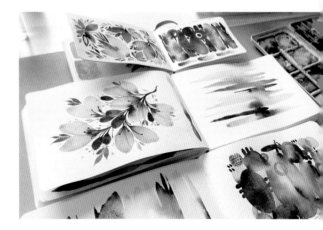

Record your ideas

The main purpose of a log is to record your ideas so
you can easily find them later and use them to cre-
ate very personal compositions. For me, this process
has become a truly meditative pleasure. Sometimes
I lose myself in the colorful shapes in my logbook,
propelled into the possibilities of how the different
elements might work together.

Just like a research scientist, you will carefully record the colors that you have discovered through your blending experiments.

This logbook is also a great tool for combining shapes with the color palettes you've explored.

The examples given below illustrate how my color palettes can be viewed both as abstract watercolors and as plant motifs.

The abstract watercolors that I make for fun are a quick way for me to visualize how these colors can be combined through blending or transparency. Using plant motifs allows me to play with colors in a more concrete way by varying the contrasts (see lesson 6).

TIP Keeping a copy of your color charts in your logbooks can be very useful.

Step-by-step

In order to get a good idea of the range of possibilities offered by your palette, try this fun exercise! The principle is simple: mix each of your colors and bring them together. Here, I've combined the 12 colors in my Bréhat palette, but you can do it with any palette.

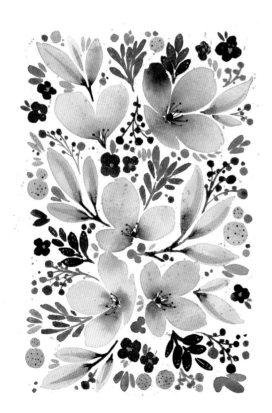

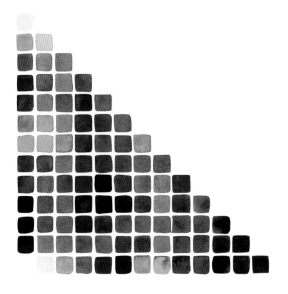

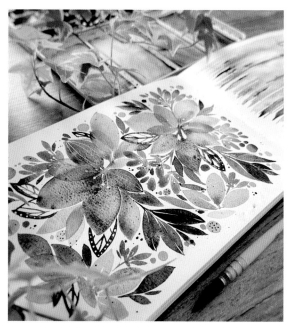

TIP The colors will vary slightly depending on the amount of water and pigment you use to mix them.

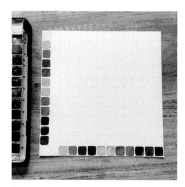

1. On a 7" x 7" square sheet of paper, draw ½" squares for 13 horizontal and 13 vertical columns (as many rows as you have colors in your palette, plus one square in the lower left corner that will remain empty).

2. Place colors in the first vertical column and the first horizontal row, in the same order as in your palette.

3. Blend the two colors that meet at the intersection of the horizontal and vertical columns.

1.

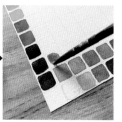

2.

3.

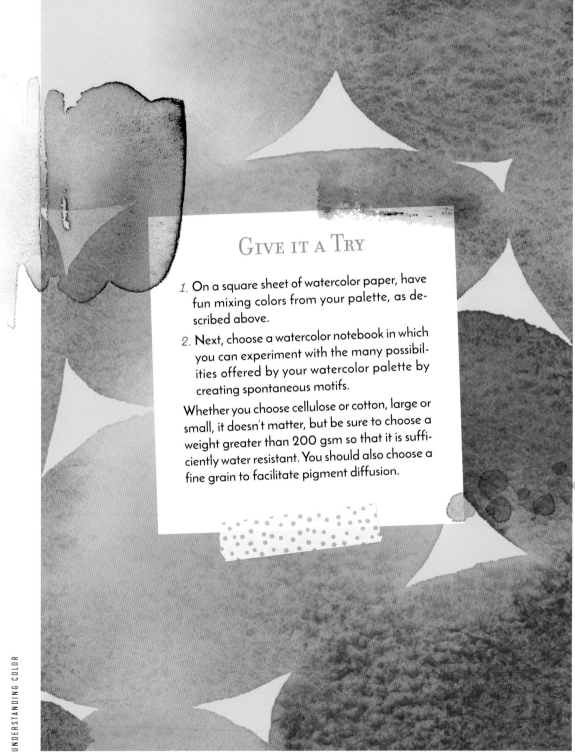

Give it a Try

1. On a square sheet of watercolor paper, have fun mixing colors from your palette, as described above.

2. Next, choose a watercolor notebook in which you can experiment with the many possibilities offered by your watercolor palette by creating spontaneous motifs.

Whether you choose cellulose or cotton, large or small, it doesn't matter, but be sure to choose a weight greater than 200 gsm so that it is sufficiently water resistant. You should also choose a fine grain to facilitate pigment diffusion.

WORKING WITH HANDMADE WATERCOLORS

LES COULEURS VF

Tell me about yourself, how did you start your business?

My name is Valentine, I'm a 35-year-old pharmacist and mom to two little boys, and I first came across watercolor painting on Pinterest in August 2017.

I'm Florence. I'm 50 years old, an instructor, mom to one adult son, and I've been painting with watercolors since 2018.

We first got to know each other in the spring of 2018 during an Instagram watercolor challenge hosted by Marie from "Tribulations de Marie." We got along like a house on fire. Then, a few months later, we realized that we lived in the same city!

In the spring of 2019, we were able to meet up with other watercolor devotees with whom we had bonded, and we wanted to surprise them with our own handmade watercolor paints.

Following this pilot, thanks to the encouragement of our friends and our community, we started selling our pans on a platform. It was during this wonderful gathering that Les Couleurs VF was formed. The name and the logo were developed within this group context. "Les Couleurs" (The Colors) refers to our little pans and the love we have for color itself, and "VF" stands both for the initials of our two first names and for "Version Française" (French Version).

Tell me about your passion and what you love about your job.

Our greatest passion is painting, but we also love finding color combinations! It's a real pleasure to create new colors and at the same time ensure the best quality, something we pay special attention to because of our own use of watercolors.

We're lucky to be able to work together and be in harmony across our different activities. Here are some of our favorites:

- Creative meetings to choose colors, discuss trials, match colors in a set, choose the packaging and themes, and talk about partnerships. All this over a nice cup of tea and some sweet treats!
- Grinding the pigments, because it's very meditative!
- Reading messages from our customers and, even more, seeing the pieces painted using our colors.

Pigments for the color: Pottery Pink

Pigment muller used to grind the pigment and blend it thoroughly with the binder to produce the creamy paste that is the watercolor paint.

What are some of the difficulties you might encounter?

We live in a consumer society, in which everything is easily and instantly accessible, and it's a shame that some people are unable to deal with the frustration of not being able to buy our products off the shelf.

Our constraints remain those inherent to all "handmade" and top-quality craftsmanship. Thankfully, we have a great community behind us.

What is your creative process?

We often begin with two colors that speak to us—that call out to us. We're inspired by nature, by the colors that surround us in our daily lives and that resonate within us!

Then follows the search for pigments, blends, and balancing in order to achieve colors and later, "poetic" sets of colors that tell a beautiful story!

What motivates us is the fact that there are two of us—it's a real driving force! We motivate and support each other, and this is a real blessing. And, of course, the feedback from our customers. There's nothing more motivating than knowing that we've contributed, in our own way, to the creative processes of hundreds of people—what an absolute joy it is seeing so many wonderful pieces on a daily basis!

Instagram: @lescouleursvf
Website: www.lescouleursvf.com

LESSON 5

CONTROLLING
THE WATER

WATER IS THE ESSENTIAL INGREDIENT IN WATERCOLOR PAINTING. IT PROVIDES
THAT ELEMENT OF UNPREDICTABILITY THAT MAKES THIS MEDIUM SO SPECIAL
AND MAGICAL IN MY EYES. ITS COURSE CAN BE CONTROLLED IN ORDER
TO PRODUCE SOMETHING PRECISE AND INTENTIONAL, BUT YOU CAN ALSO
CHOOSE TO LET IT DO ITS OWN THING FOR MORE UNINTENDED RESULTS.

Blending

The water moves around the pigments: it can push them, attract them, diffuse them, and blend them. Understanding how water makes watercolors come alive is a very important aspect. Let's take a closer look at the different ways we can guide our watercolors using water.

Refer also to my interview with Stephanie Ryan (page 58), who has the ability to make her pigments dance through amazing water and color management.

I call the exercise that follows "pebble blending" because the oval shapes you will paint are reminiscent of those small stones found at the water's edge. Some artists explore abstract art by working with geometric shapes in different ways.

Watching the water make the pigments communicate with one another is quite satisfying. With this method, you will learn how to guide the pigments or simply let them be. Indeed, on some "pebbles" I attract the pigments, while on others I push them away.

I produce these results through the amount of water and pigment on my brush, as well as the way I move my brush on the paper.

After selecting a color palette, I had fun blending the colors in the pebble exercise.

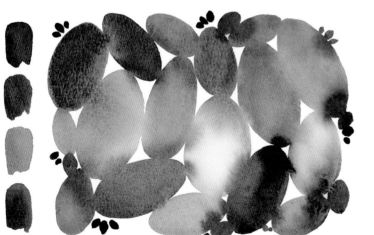

After selecting a color palette, I had fun blending the colors in the pebble exercise.

Step-by-step

1. Before starting, secure the sheets in your notebook with a clip to prevent the paper from curling when it comes into contact with the water.

2. Prepare the colors you're going to use. On one corner of the page, note down their references so you don't forget them later.

3. Choose the first color from your selection and place it in the corner of the paper, painting it into a pebble shape. To do this, mix the paints with lots of water in the wells on your palette, creating a thin paint liquid, so the pigments will move more easily from pebble to pebble when you put them on the paper (see lesson 8).

4. Gradually add new pebbles around the others. Vary the colors and the amount of pigment in your wells by adding more or less water to the mixture, creating as much contrast as possible (see lesson 6) between pebbles. (Sometimes I form pebbles with only water and no pigment, so I can use the ones already on my paper. With enough water, I can attract them, as the pigments will go where the water is most abundant.) The exercise must be done quickly enough so the pebbles don't dry out and lose the desired blending effect. The pigments move from pebble to pebble and create interesting mixtures. This allows you to quickly see the color balance between them.

EQUIPMENT

– An A5 notebook in 230 gsm from Etchr Lab

– Aqua Aura Colors handmade watercolors: Eucalyptus, Burdigala, Gray Sky and Chestnut

– A Princeton Neptune size 10 brush

– A binder clip

1.

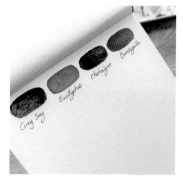

2.

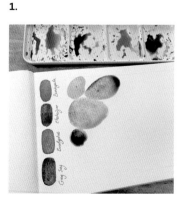

3.

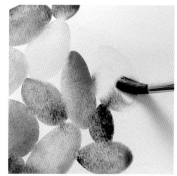

4.

5. When the paint is dry, have fun doodling on your pebbles to embellish them. It's a very relaxing and visually interesting exercise.

TIP Pay close attention to the amount of water you put on your pebbles. It's sometimes necessary to remove some of the excess water to allow the pebble to dry evenly. This will prevent the "halo" effect, i.e., the creation of demarcations due to the paint not drying evenly.

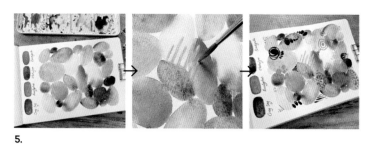

5.

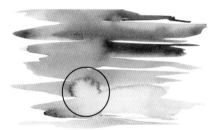

Halo effect

Also, if one pebble is almost dry when you add another, the pigments will be hard to push and will also create "halos."

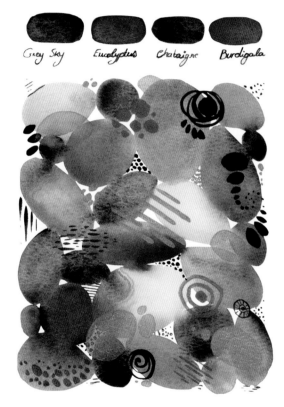

Grey Sky Eucalyptus Chataigne Burdigala

Layering

When the water has completely evaporated, all you'll see on your paper are the traces left by the watercolor pigments. Placing multiple layers of pigments on top of each other provides new perspectives to your pieces. I use this technique a lot in my compositions, adding to the interplay with transparency that comes from properly managing the quantity of pigments used.

You need to contrast the layers as much as possible to avoid smothering your watercolors. Indeed, if not well-balanced, this technique can produce a very muddled effect. I often apply the lighter watercolor as a first layer and gradually increase the amount of pigment with each new layer. This technique requires waiting for the paint to dry completely before applying a new layer of paint.

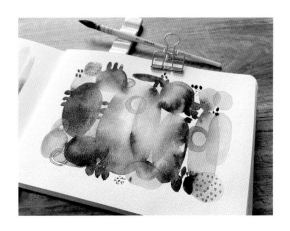

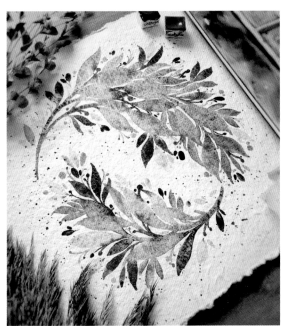

I had fun here creating two leaf designs entirely based on blending. I let the pigments move randomly. Occasionally, I went back to some areas that were still wet to put in new touches of darker pigments, and thus bring in contrasts.

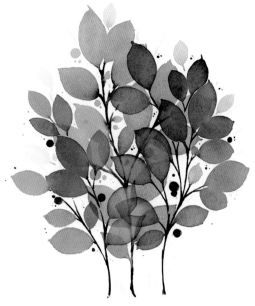

GIVE IT A TRY

1. Start by choosing a palette of three or four colors.
2. On two opposite pages in your notebook, work on blending on one side and on layering on the other, so that you can compare the two effects.

Layering can be experimented with using pebble shapes, same as for blending, but you can also choose any other pattern.

Be sure to apply the first layer with a very thin paint liquid and wait for it to dry before applying a second layer.

PLAYING
WITH CONTRASTS

TO BRING PERSONALITY AND INTRIGUE TO YOUR ARTWORK, PLAY WITH THE
CONTRASTS THAT WILL BRING OUT YOUR COLORS. IF THEY'RE WELL EXECUTED,
YOUR PIECES WILL CATCH PEOPLE'S EYE AND HOLD THEIR ATTENTION LONGER.

Color contrasts

The more concentrated the pigments are in a watercolor paint, the more saturated its color is—color saturation being at its highest when it first comes out of the tube or pan.

To add contrast to your pieces, you can, for example:

- Contrast desaturated colors by adding paint in shades like sepia, neutral, or black to your blends to dull the color, and contrast saturated colors with more vivid and colorful shades.

- Play with levels of transparency—the more water you add to your blend, the more you'll decrease its value (see lesson 8).

- Play with warm and cool colors (see lesson 3) to add eye-catching color combinations to your compositions.

Contrasting shapes

Another type of contrast that's essential in creating compositions is that of shapes. For example, if you're planning to paint a flower arrangement, I suggest you include two or even three different flower varieties (which can be imaginary or real),

as well as varying their sizes. A combination of small and large flowers facing in different directions gives a composition balance and a variety of motifs (see lesson 10).

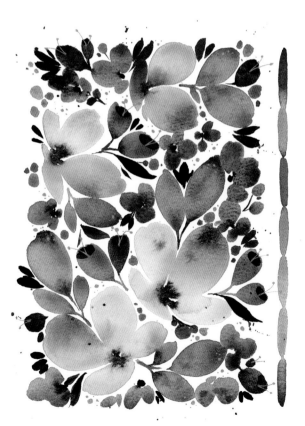

Combining contrasts

When we're trying to achieve consistency in a composition, we need to know how to combine several sets of contrasts so that our eye doesn't get bored with repeated motifs. This is why I'm always careful not to concentrate all the elements of the same color and shape in the same place, but rather to distribute them in such a way as to create echoes in various parts of my composition.

TIP It's entirely possible to combine several contrasts within a single piece; the key is knowing how to proportion and adjust each element in relation to the others. Sometimes you will have to start over or rethink the overall balance of your composition, but I advise you to always follow through with your idea, because that's how you will progress.

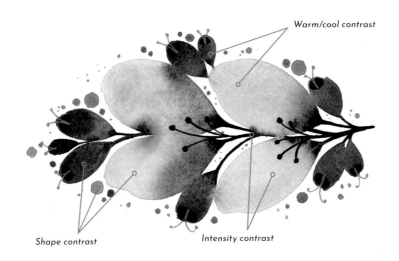

Warm/cool contrast

Shape contrast

Intensity contrast

GIVE IT A TRY

Now it's your turn to create beautiful contrasts using your palette.

1. First, choose a few colors from your palette and play with their depth and saturation levels using water and desaturating colors.

2. Have fun experimenting with geometric shapes on your paper to vary the shape contrasts, in combination with color contrasts. Make wider or narrower strokes, larger or smaller circles, dots, etc.

3. Repeat your pattern, adding new shapes and contrasting colors.

FINDING
PALETTE IDEAS

DURING MY RESEARCH, I NOTICED THAT THE MORE I INADVERTENTLY
MADE MISTAKES WHEN BLENDING COLORS, THE MORE I LIKED THE RESULT.
SO, I GRADUALLY BROADENED MY COLOR HORIZONS, PARTICULARLY
WHEN IT CAME TO THE WORLD OF PLANTS. AS I CONTINUED ALONG
THIS JOURNEY, I STOPPED ASSUMING THAT A COLOR ONLY HAD ONE
ROLE. AS A RESULT, I MULTIPLIED THE POSSIBLE COMBINATIONS IN
MY COMPOSITIONS TENFOLD AND EXPANDED MY CREATIVITY.

"Signature" colors

These are the colors that most identify a painter's artistic style. Sometimes it's not really about the colors themselves, but rather about the mood of the colors and how you use them. For example, I often use color palettes that I like to tone down by adding a neutral tint.

Therefore, there are very few bright colors in my paintings.

There are an infinite number of color palettes to discover. Sometimes they are revealed

through images or photos that inspire us, and other times they're the result of creating our research projects. Like a funnel, our inspiration can carry us to more personal palettes that appeal to us.

Researching colors is quite a task, and one that's just as important as creating a successful composition. To me, a beautiful color palette is 50% of the process of creating a beautiful composition, so I place a lot of importance on this step.

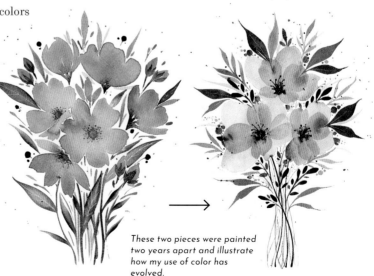

These two pieces were painted two years apart and illustrate how my use of color has evolved.

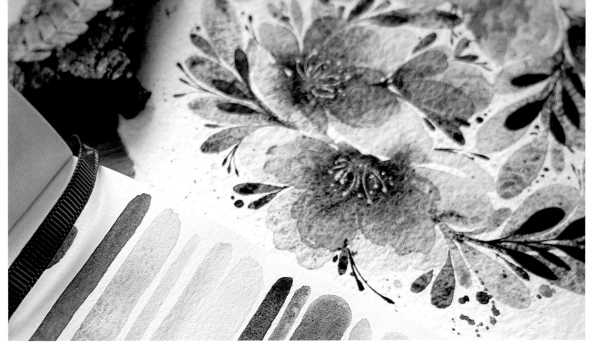

A color palette inspired by the book Palette Perfect.

On a day-to-day basis, keep in mind that half of my palettes come from the painting I do as part of my watercolor research (see lesson 11). The other half come from palettes found on Pinterest and Instagram, or from photos I've taken myself. Many of them have also been drawn from the book Palette Perfect by Lauren Wager, which has been a great source of inspiration for me.

Putting together your own palettes

Today's mobile phones allow us to take stunning photos that can be used to create color charts. With no real photography experience, I was able to take the three pictures on the right quite easily. The first two were taken with an iPhone 7 and the third with an iPhone 12.

I then used two applications that are available on both iOS and Android:

- **SnapSeed**, to do some retouching on my photo (contrast, saturation, etc.).

- **Coolors**, to add a palette of colors from my photos on the right-hand side.

TIP It's not always easy to reproduce a color from a photo or a digital palette in watercolors, so by creating color charts (see lesson 3), you'll become more and more comfortable with mixing colors. Keep in mind that if you want to lighten a watercolor, you will need to use water rather than white (see lesson 8).

Step-by-step

1. When creating a color chart from a picture, first take a photo with a smartphone (in this case, I used an iPhone 7 Plus). To create a perspective blur, get as close as possible to your subject so the lens focuses on it and creates a blurred background.

2. Next, open the Snapseed app and adjust the saturation, shadows, and focus effect, if necessary. Using the Selective tool, you can highlight certain areas, which can be very useful.

1.

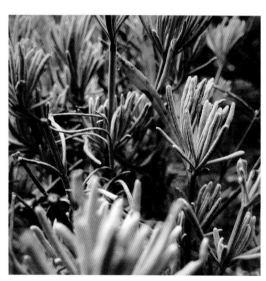

2.

3.

3. Open the second app, Coolors. In Other Tools, search for one of your photos (Browse photos). In the lower right corner, the + and - buttons allow you to reduce the number of colors that are displayed. Personally, I like to stick to just four or five colors, as I don't usually use more than that in my pieces.

The app will also suggest some palettes based on your image.

They're often really useful and I find them helpful. To change a color, simply select it and drag the dot on the image to the desired location.

Then, using the Create Collage option, you can insert the colors onto whichever part of your photo you wish.

4. Lastly, you just have to export your picture.

Give it a Try

Create your own color chart based on a photo or particular subject.
1. Select the four dominant colors that best convey the image's mood.
2. Try to capture them as accurately as possible using the colors in your palette.

LESSON 8

REPRODUCING A
DIGITAL PALETTE WITH WATERCOLORS

REPRODUCING A DIGITAL PALETTE IS A VERY EFFECTIVE WAY OF
LEARNING HOW TO MIX COLORS AND MANAGE WATER QUANTITIES.
IN FACT, YOU CAN CREATE AN INFINITE NUMBER OF DIFFERENT
COLOR PALETTES USING ONLY A FEW WATERCOLOR PANS.

Color values

The value represents the various transparency levels of your colors, from the most concentrated to the most diluted. The more water you add to your color, the lighter or more transparent it will appear. This information is particularly useful when you want to add contrast to your artwork.

Here are some examples of values. These are the colors that I'll use to make the blends shown below.

I've added a small key above my columns so you can see the different dilution levels in my colors:

P. = pure color

N_1 = first dilution level

N_2 = second dilution level

N_3 = third dilution level

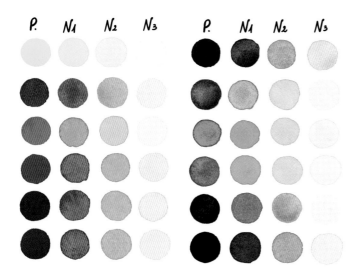

Names of the colors in the first column: Light Yellow, Venice Red, Dalbe Orange, Helios Red, Deep Rose Madder, Helios Purple (Bréhat range).

Names of the colors in the fifth column: Van Dyck Brown, Olive Green, Hooker Green, Dark English Green, Ultramarine Blue, Paynes Gray (Bréhat range).

Lightening a color

I've chosen this olive green as an example to show you how I decrease the value of my color. The process is the same for every other color.

1. After wetting my brush, I lightly rub my pan to get a fairly concentrated pigment.

2. Then, I put the color on the left side of my watercolor paper. I label this color "P.".

3. I dilute this color once and label it "N1". To do this, I dip the tip of my brush into my glass of water, then dilute the color in the well on my watercolor palette.

4. I then place this color to the right of the first (P.), so as to differentiate them.

5. I repeat the process a second and third time, in order to dilute my color two further levels, which I will call N2 and N3 for the respective lighter colors.

 If you want to darken a color, follow the same process using black, Paynes Gray, sepia, or another neutral tint.

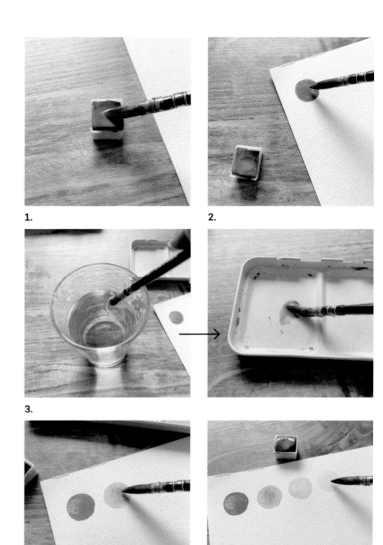

1.

2.

3.

4.

5.

Reproducing colors

I chose to reproduce two random color palettes from the Coolors app. I used the Generate button at the very bottom of the app's home screen.

None of these colors are in my palette, so I'll have to do some mixing and greatly decrease some values to get them.

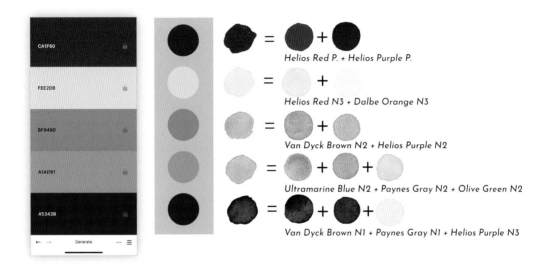

Helios Red P. + Helios Purple P.

Helios Red N3 + Dalbe Orange N3

Van Dyck Brown N2 + Helios Purple N2

Ultramarine Blue N2 + Paynes Gray N2 + Olive Green N2

Van Dyck Brown N1 + Paynes Gray N1 + Helios Purple N3

GIVE IT A TRY

First, experiment with your color values by gradually diluting them with water to about three levels of dilution. This will allow you to see what your colors look like at different levels of transparency.

Next, do the exercise of reproducing the two digital palettes opposite, which I generated with the Coolors app. Make sure that you note down the references of the colors you have used and their dilution level (P., N1, N2, N3).

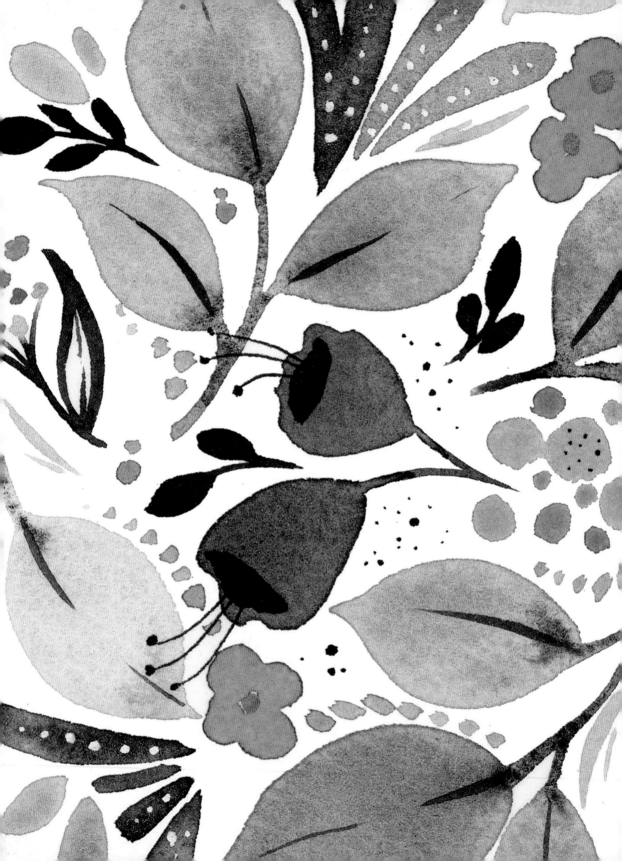

CREATING PLANT MOTIFS

Creating plant motifs will help you get a better handle on your floral compositions. In this section, I will explain how you can create your own motifs so you can develop your own modern watercolor style. Based on real elements, taken from your own photos or from inspirational images found online, you'll be able to build up a portfolio from which you can draw ideas for a variety of compositions.

DISCOVERING
MODERN WATERCOLOR

CREATING MOTIFS USING A PAINTBRUSH CAN BE QUITE DAUNTING. OUR BRUSH HANDLING CAN SOMETIMES BE DIFFICULT AND AWKWARD. HOWEVER, THROUGH PRACTICE AND EXPERIMENTATION ON CELLULOSE PAPER, YOU'LL SOON DEVELOP FLUIDITY. MODERN WATERCOLOR IS ALL ABOUT INTERPRETING SHAPES, WHICH ARE MADE USING JUST A FEW MOVEMENTS WITH THE PAINTBRUSH.

Simplifying real-life subjects

Modern watercolor is primarily characterized by its emphasis on simplifying the elements in a painting as much as possible. Details are kept to a minimum and movements are light and instinctive. It's best not to do a detailed sketch beforehand so you don't hinder the spontaneity! In practice, however, I often mark out shapes on my paper when I have a clear idea of what I want to paint. For example, I sketch a rough outline of the elements in pencil so I remember their placement, size, and shape.

Any subject can be simplified, as long as you keep these key points in mind:

- Bring out the play of light and shadow in order to give volume to the elements.

- Keep the most important details. If you want to paint a hellebore, for example, you should remember that it has five petals and include these in your painting.

This exercise requires a little practice, but will soon become instinctive. We're not looking for the perfection of realism here, but rather simplifying the style and stages of creating a composition (see lesson 11).

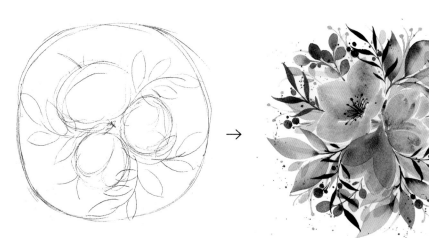

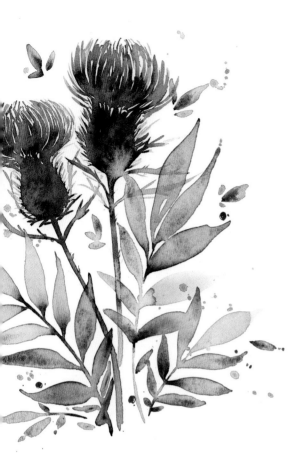

1. First, take time to analyze the flower: its shape, movement, areas of light and shade, etc.

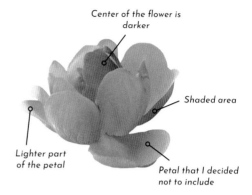

Center of the flower is darker

Shaded area

Lighter part of the petal

Petal that I decided not to include

2. Next, start mixing in one of the wells on your palette, trying to find a color that's close to that of your subject. (I chose Sennelier's Opera Pink for the lighter parts of the petals and Van Gogh's Twilight Pink for the shaded parts.)

TIP You can use everyday objects, animals, and people as subjects for your modern watercolor paintings. This technique is by no means limited to portraying plants.

Step-by-step

I chose to produce a modern watercolor rose based on a real one, as it's a flower that can easily fit into any floral composition. It takes practice, but if you can paint this one, you can paint any other flower. Keep in mind that there isn't just one way to interpret a subject in modern watercolor, but many.

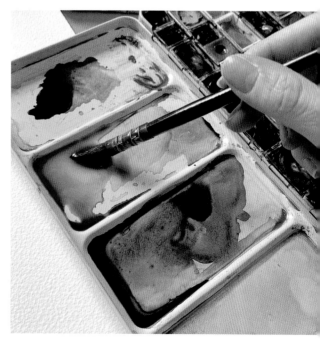

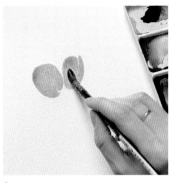

3.

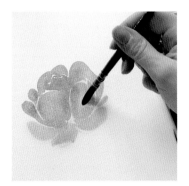

4.

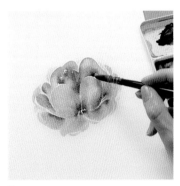

5.

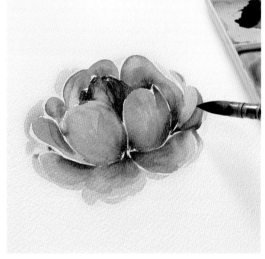

6.

3. Start by painting the two main petals. Make sure to leave small gaps between each element to keep them separate.

4. Add new petals around the first two, trying to follow the flower in the photo.

5. Mix your two paints together to get a darker shade. With this new blend, add depth to the flower by adding shaded areas.

6. When the painting is dry, add slightly diluted pigments to create transparent shadows, which add volume.

TIP You can use cellulose paper to practice on, as it's cheaper than cotton paper. When you feel ready, move on to cotton paper so you can enjoy the beautiful blending of colors.

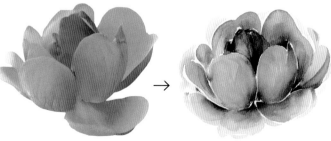

GIVE IT A TRY

1. Look around you for a subject (plant, object, animal, etc.) that you would like to paint in the modern watercolor style.

2. When you have found your subject, take a moment to analyze how the light gives it life, as well as its proportions and important details.

3. Practice on a sheet of cellulose paper to perfect your movements and how you build the subject. To do this, trace the shapes with your brush without sketching, simply interpreting what you see. Try to add depth by experimenting with the concentration of pigments in your palette.

4. When you feel ready, prepare some color blends to match those of your model.

5. Take the plunge! Paint your subject's distinctive shapes on a sheet of cotton paper. Don't focus on precision or detail, but rather on the overall consistency of your composition.

COMPILING
A COLLECTION OF MOTIFS

JUST LIKE THE BLENDING LOG (SEE LESSON 4), IT'S VERY USEFUL
TO COMPILE A COLLECTION OF MOTIFS. INDEED, LIKE CREATING AN
HERBARIUM, YOU CAN PUT TOGETHER A COLLECTION OF PLANT
MOTIFS THAT WILL INSPIRE YOUR FUTURE FLORAL COMPOSITIONS.

Finding inspiration

Finding new sources of inspiration isn't easy. I'm
very familiar with that feeling of being caught in a
loop of the things I've mastered. To avoid getting
bored, I try to vary the motifs I use as much as pos-
sible and incorporate my personal flair (which often
comes from my color palette). I look for inspiration
in a variety of places, including books, Pinterest,
Instagram, or simply all around me, such as in my
garden.

Finding your own unique signature is a journey
that can take time. Personally, I took many detours
in my art before I found what I liked best. Therefore,
it's essential that you practice regularly and experi
ment as much as possible in order to discover what
you like to paint the most.

TIP Here are a few books that have inspired
me:

- *The Flower Recipe Book* by Alethea Harampolis and
Jill Rizzo

- *Palette Perfect* by Lauren Wager

- *The Flower Year and Floribunda* by Leila Duly (col-
oring books)

- *Natural Companions, The Garden Lover's Guide to
Plant Combinations* by Ken Druse

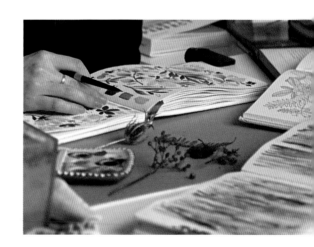

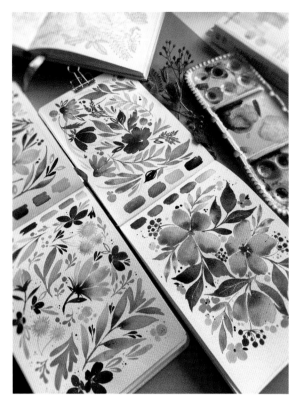

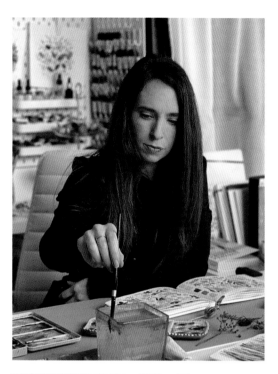

I often try to branch out into more imaginary flowers when designing plant motifs to add a touch of fantasy to my bouquets.

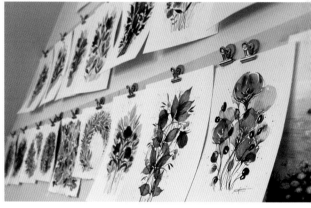

I often try to branch out into more imaginary flowers when designing plant motifs to add a touch of fantasy to my bouquets.

When I spot something I like, I try to record it fairly quickly in my notebook so I don't forget it. Often, a small sketch is enough because the important thing is just to keep the idea, in the same way as with the blends that we like.

Getting organized

I work very much on instinct, but as time has gone by, I've felt the need to better organize my creative process, and my precious notebooks help me consolidate my ideas so I can get a better start on new watercolors.

Additionally, the layout of my studio is very important to me, as it helps me focus and be more efficient. I'm lucky enough to be able to display many of my favorite watercolors on one of my walls and they inspire me to come up with new ideas.

All this helps me to be better prepared when I tackle a new composition.

1.

2.

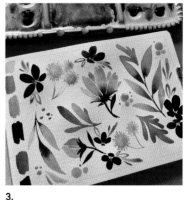

3.

Step-by-step

One of my sources of inspiration for creating motifs is the book, Natural Companions by Ken Druse. I've found a number of small elements from those pages that I've recorded in my notebook, have inspired me, and are easy to reuse for future compositions.

1. Choose a palette of colors using your blending log. If necessary, create a new one, making use of the method in lesson 7.

2. Use a new page in your motif notebook and mark out an area with a pencil. In my case, it will be rectangular, as my notebook has a landscape format. On the left side of the page, I note the colors I'm using. If necessary, you can write the names of these colors next to the rectangles.

3. Create a few motifs and then repeat them at different angles to fill the page.

4. Fill in the blanks with various shapes of different sizes (small leaves, dots, circles, etc.). I try to assign a color to each motif and to vary their location as much as possible, like in a pattern.

TIP A pattern is a repeated motif, most often used for printing on textiles.

TIP I differentiate between the main flowers, secondary flowers, and plants according to the importance I give these floral elements in my composition.

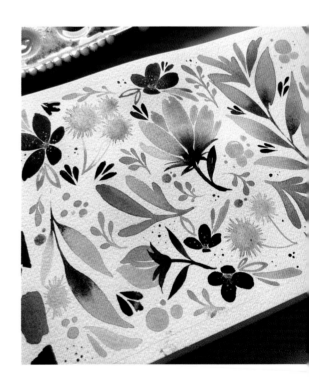

GIVE IT A TRY

I recommend getting a second watercolor note-book to distinguish between the one for blending and the one for recording all your motifs. You don't have to spend a lot of money; it's all about preserving your ideas and experimenting.

Having two notebooks will allow you to view your color and motif ideas at the same time when creating a floral composition.

In your notebook, play around with the following motifs:

- Main flowers: roses, anemones, peonies, etc.
- Secondary flowers: lavender, thistles, cosmos, etc.
- Miscellaneous foliage: branches, berries, burnet, etc.

KNOWING HOW TO LET GO

STEPHANIE RYAN

Tell me a bit about yourself.

My name is Stephanie Ryan and I'm an intuitive artist, writer, and teacher. I live in a small cottage in the middle of a horse farm in Pennsylvania where I spend my days painting, teaching, and running my creative business. My art is featured on a wide range of products, including greeting cards and stationery, home decor, textiles, and more.

How did you get started with watercolors?

I started painting with watercolors about 10 years ago and just fell in love. It was a difficult period in my life and through exploring watercolors, I discovered a profound calling to create art and words that inspire, encourage, and comfort. It was during this time that I developed my own style, which consists of ethereal flowers, abstract landscapes, and organic intuitive paintings, all in an effort to connect with others.

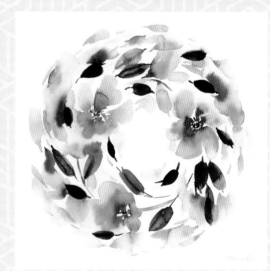

Peace Within

What do you like most about watercolors?

I love the magic of watercolors. You can achieve the most amazing effects when you surrender control and let the watercolors do the work for you. The less you try to control them, the better the result.

How do you find inspiration?

As an intuitive painter, I look inside for inspiration. My goal as an artist is to paint what my soul feels. In doing so, I'm able to communicate with others who can relate to the way I'm feeling. I find this connection deeply inspiring.

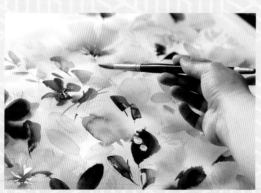

Serendipity

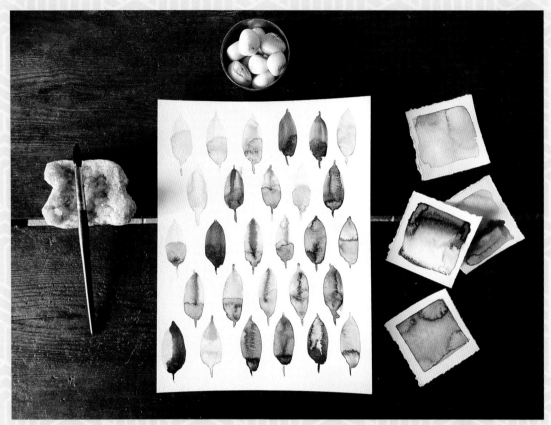

Get Grounded

Can you tell me a bit about your creative process?

I believe that art should be a sacred practice involving ritual and meditation. By freeing my mind and being quiet, I'm able to create a peaceful space that allows me to connect to my intuition and find inner inspiration. In this meditative space, I see colors and images, and connect to my feelings. I then paint this experience through flowers, landscapes, abstract motifs, and symbols. This process allows me to connect more fully with my art and create something deeply meaningful.

What advice would you give to help someone improve their watercolor skills?

Approach your art with a sense of wonder. Get the colors and water flowing, and trust that they will blend in a beautiful way. Let the materials do the work for you. Surrender control, find your flow, and trust the process. Remember that beauty is found in imperfection, not only in art but also in life.

Instagram: @stephanie.ryan.artist
Website: stephanieryan.com

CREATING A
WATERCOLOR VALUE STUDY

AT FIRST GLANCE, WATERCOLOR VALUE STUDY SHOULD BE INSPIRING.
IDEALLY, THE COLOR PALETTE AND MOTIFS SHOULD BE VARIED AND
CONTRASTING, OFFERING CONCRETE IDEAS ON A CHOSEN THEME.

Looking for ideas

Watercolor value studies help you start a new piece more efficiently, as they give a quick overview of the concept you want to work on. They provide a good overview of the subject and help you come up with ideas in an organized way.

You can create as many as you like on a variety of themes, such as fall, Christmas, insects, flowers, plants, etc. You can then gather all your ideas together in a place that will be most helpful to you in your search for inspiration (in a specific binder or on a wall, for example).

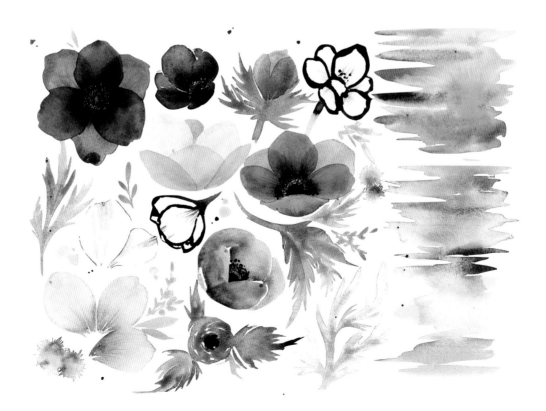

Improving your studies

Whether all around you, on Pinterest, or in books, there's no shortage of inspiring subjects to delve into. Take pictures of your subjects from multiple angles to better understand them and make them your own. For example, if you want to explore roses in your watercolor value study, choose images showing a sealed rose, an open rose, one seen from above and from the side, one in bud, etc.

Once you have gathered your reference images, select a color palette and place it in the corner of your study sheet.

You can choose to start with the same range of colors as in your inspiration photos, or develop a whole new palette, depending on the mood you want to capture.

The result of such a study should include motifs of various shapes, sizes, and prominence to provide relevant ideas for future compositions.

TIP Make sure you have as many different sources of inspiration as possible so you can preserve your own style. Starting from a real subject allows you to make its style and form your own.

Step-by-step

I decided to create a watercolor value study on anemones. It's a flower whose shape and style I really like, and I find that it blends in easily with any type of floral composition.

1. Open Pinterest and plant books and look for colors that work best with your subject. Place color samples in a corner of your study.

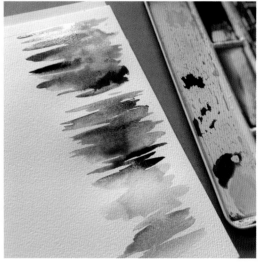

1.

2. Going back to books and Pinterest, look for a wide variety of images on the theme of anemones to cover it as broadly as possible. Make sure to select a collection of images that you think would be easy to reproduce as a modern watercolor.

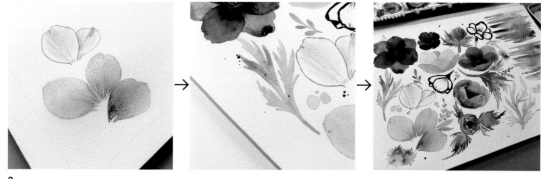

3.

3. Put together a color palette that you like, inspired by the colors in the images. Next, recreate your selected elements with watercolors.

TIP With a tool that has a fine, rigid tip, you can make small grooves in the wet watercolor in which the pigments will stagnate and appear darker, even when the paint is dry.

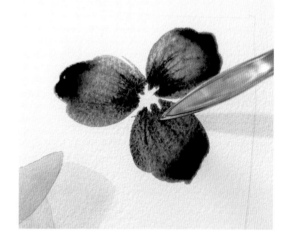

I used a letter opener to mark fine lines on my wet painting.

GIVE IT A TRY

1. Select a sheet of watercolor paper that's large enough to accommodate a variety of elements.
2. Choose a theme that you'd like to explore, such as the sea, insects, fish, mountains, etc.
3. Using keyword searches on Pinterest, immerse yourself in this world and put together one or more color palettes that inspire you.
4. Paint all the elements you've selected on your sheet of watercolor paper, experimenting with your color palette. Be sure to vary the shape and orientation of your elements to make your study more visually engaging.

MAKING THE COLORS
YOUR OWN

TO MAKE MY WATERCOLORS MORE PERSONAL AND ORIGINAL, I ALMOST ALWAYS MODIFY MY SUBJECT'S COLORS, USUALLY WITH THE HELP OF MY BLENDING LOG. I FOCUS FIRST ON A PALETTE THAT INSPIRES AND GUIDES ME, THEN I ENVISION WHICH COLOR WILL BE DOMINANT IN MY WATERCOLOR AND WHAT THE KEY ELEMENT IN MY COMPOSITION WILL BE. I ALSO CONSIDER WHICH COLORS WILL BRING IN SOME NICE CONTRASTS.

Modifying the colors

Changing the colors can actually become a bit of a game. Looking for new color combinations fascinates me, and I try to diversify my ranges as much as possible. I frequently use a reference image to imagine new combinations. Sometimes, I only change one detail from the original model, while other times I change a lot of things.

TIP Managing color balance isn't something that you learn overnight; it requires a lot of work and observation. As you go along, you will improve and have the courage to experiment with original and atypical combinations.

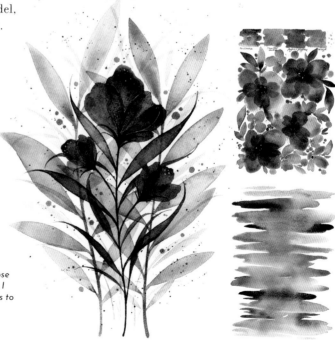

My flowers are often inspired by cosmos, hellebores, or poppies, whose colors and shapes I modify slightly. I sometimes add little fantasy details to make them unique.

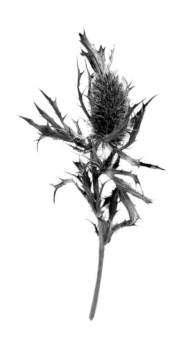
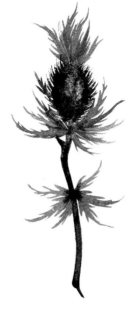

For my thistle, I used Lunar Black mixed with Moonglow by Daniel Smith, and Fiel Stone by Sennelier.

Step-by-step

1. First, choose the subject you want to paint with watercolors. Here, I've chosen one of my dried thistles. Using a real model allows for a more authentic result.

2. Select a palette of colors, using your blending log, if necessary.

3. Select which of the model's colors you want to replace.

4. Paint your watercolor in your motif notebook to keep a record of your research. The result is a unique and personal piece.

GIVE IT A TRY

1. Open your motif notebook to a new page or select a new sheet of paper, either cellulose or cotton, depending on your preference.

2. Select a few reference visuals, either ones you've photographed yourself or taken from Pinterest.

3. Select a color palette from your studies.

4. Prepare your blends on your palette.

5. Paint your piece, using different colors than those in your reference images and experimenting with blending and contrasting (see steps 5 and 6).

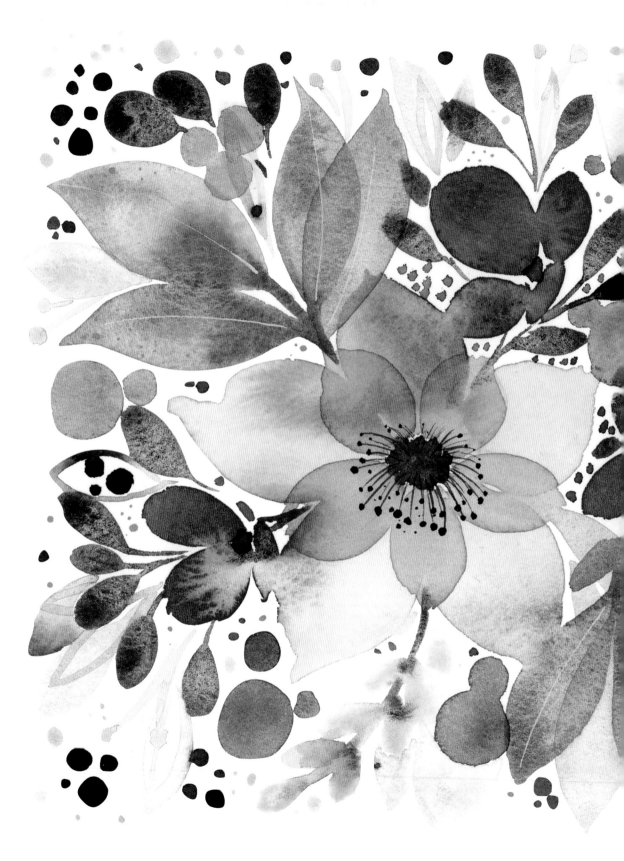

PART 4

CREATING
A FLORAL
COMPOSITION

This chapter focuses on putting into practice
what we've covered in the previous steps. I'll
explain how I use my notebooks to create my
modern watercolor floral compositions. I've also
included some tips on how to create simple and
balanced flower arrangements.

USING
YOUR RESEARCH

IN THE PREVIOUS LESSONS, WE'VE LOOKED AT HOW TO COLLECT MOTIFS
IN OUR RESEARCH NOTEBOOKS AND THEMED WATERCOLOR VALUE
STUDIES. YOU'LL NOW LEARN HOW TO USE ALL THESE ELEMENTS TO
CREATE YOUR OWN PERSONAL AND ORIGINAL FLOWER COMPOSITIONS.

Observing your source of inspiration

Learning how to put motifs together to create a composition is more difficult than it sounds. Something that can be very beneficial when you're about to start a flower composition, for example, is looking carefully at a bouquet produced by an expert florist. Look at it closely in order to understand what makes this bouquet pleasing to the eye. Is it the color balance, the way the flowers are arranged, or the choice of plants? By taking the time to analyze several bouquets, you will realize that all these arrangements have been carefully designed by the florist. You can, of course, practice reproducing florists' bouquets with watercolors, using fewer and more simplified elements. However, if you want to put together a bouquet using your own motifs so that it's unique, you're going to have to learn how to incorporate all your elements into the composition.

Let's first take a look at a bouquet put together by an expert florist.

To create good balance in their bouquets, florists play with contrasting shapes and colors. Everything is carefully arranged in such a way to create a well-thought-out geometry.

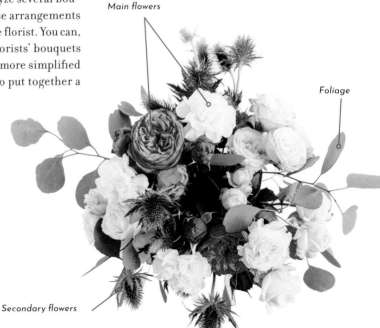

Main flowers

Foliage

Secondary flowers

Selecting your motifs

All the motifs you have collected in your notebooks will be used to enrich your compositions, allowing you to choose from a wider and more personal selection of elements. For my paintings, I use my notebooks to find secondary flowers and foliage. For the larger motifs, which I use as main flowers (as in the florist's bouquet), I refer to my watercolor value studies (see lesson 11).

When starting out, I recommend that you don't add too many elements to your compositions so you can more easily control how you arrange them and make sure they stay balanced.

To begin with, work primarily with:

- One main flower (anemone, rose, peony, carnation, etc.)

- Two secondary flowers (thistles, flower buds, daisies, etc.)

- Three types of foliage (umbellifer, berries, olive branches, eucalyptus, etc.)

As you gain experience creating compositions, you can play around with including more elements. But don't forget to step back and consider your composition so you don't overload it, as we'll discuss in lesson 14.

Give it a Try

Have some fun making imaginary connections between motifs and color palettes from your notebooks and watercolor value studies.

For example, create a composition using the following elements from your notebooks and themed studies:

- A color palette
- A main flower—anemone, rose, peony, etc.
- Two secondary flowers—thistles, flower buds, daisies, etc.
- Three foliage elements—umbellifer, berries, olive branches, etc.

Make preliminary sketches on a blackboard or piece of paper to help you visualize and arrange your composition.

PAINTING
FLOWER ARRANGEMENTS

IN THIS LESSON, YOU'LL USE ALL THE RESEARCH AND GROUNDWORK YOU'VE
DONE TO CREATE BEAUTIFUL FLORAL COMPOSITIONS. PRACTICING MOTIFS,
FINDING THE RIGHT BLENDS, OR, MORE GENERALLY, TRYING TO FLESH OUT
THE COMPOSITION YOU HAVE IN MIND, ARE ALL PART OF THE GROUNDWORK.

Working on the composition

I recommend testing on cellulose paper first rather
than straight onto a sheet of cotton paper.

Personally, I began my artistic adventure using Le
Rouge cellulose paper from Hahnemühle's Moulin
du Coq range, in 325 gsm. I bought blocks of 100
sheets and experimented as much as I could. Some
of these experiments are now displayed on my wall,
among my favorite watercolors.

*A bouquet shown from above on Hahnemühle
Le Rouge 325 gsm cellulose paper.*

Choosing a shape

Here, I chose to depict a bouquet viewed from above,
because I think it's a simple composition that's quite
easy for beginners—the subject is simplified by the
fact that we can't see the stems. These can often com-
plicate our pieces, as we must consider how best to
arrange them to ensure consistency with the flowers,
without making the whole look too cluttered.

When you're still inexperienced with watercolors,
feel free to study or imagine simple compositions
or viewpoints that will help you gain confidence.
Here, simply place the main and secondary flowers
in the center of your page, then gradually add foliage
around them, while judiciously filling in the emp-
ty spaces. You need to think carefully about where
each element is placed and add a few shape and color
echoes in different parts of the arrangement.

When I design my flower arrangements, I pay at-
tention to the way the elements fit together, so that
I can vary the colors and shapes. This is how I add
some contrasts to my composition.

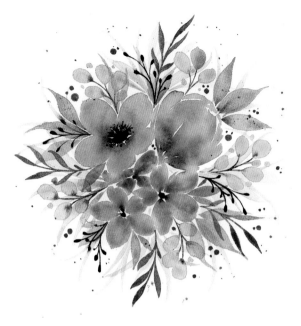

Knowing when to stop

Even today, I watch carefully for that moment when, absorbed in my piece, I miss the fact that I've fallen into the trap of "too many details." Even with experience and practice, it can be difficult to get a handle on this. To help you avoid passing this tipping point into an overloaded arrangement, take a little break once you've assembled all your elements. When you return, look at your composition from a little further away or even through a photo taken with your smartphone. This should give you a better view of any misfits and help you decide if you need to continue adding new elements.

If you feel your arrangement is lacking something, feel free to invent a small new piece of foliage or add some colorful berries to fill in any gaps.

TIP I often choose an odd number of flowers for my arrangements, because I try to break away from perfect symmetry, which tends to make the flow of the arrangement too repetitive and less natural.

Step-by-step

EQUIPMENT

– A sheet of fine-grain Lanaquarelle paper in 300 gsm and a sheet of cellulose paper for practice

– Les Couleurs VF watercolor paints: Cornflower, Bougainvillea, Bergamot, Juniper, Brocéliande and Stormy Night

– A Da Vinci Casaneo size 2 brush

– A compass

1. Find a color palette that inspires you, and try to reproduce it on a sheet of cellulose paper.

2. On this same sheet, select the elements that will make up your composition (see lesson 13).

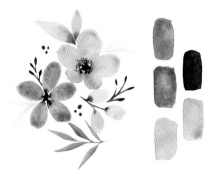

3. If I feel it is necessary, I do a small sketch on a draft sheet. When I have a clear idea, I make a start on my watercolor paper.

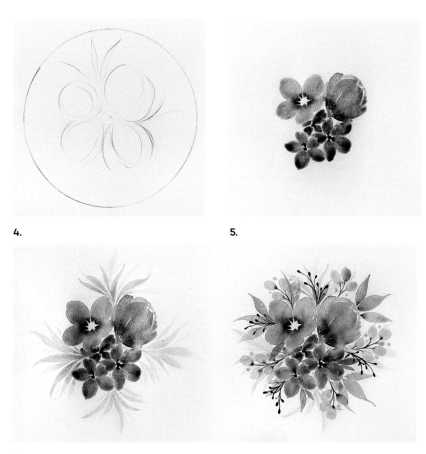

4.

5.

6.

4. Start by finding the middle of the paper and draw a light circle using a compass to outline where the arrangement will be. Next, mark the location of the main elements with circles.

5. Place the first flowers—the most important ones—then the secondary ones, trying to follow the draft you did on your first sheet.

6. Add foliage of varying sizes and shapes. Take care to spread them nicely around the flowers to create attractive color echoes throughout the arrangement.

7. Finally, fill in the blanks with small elements and add symmetry where needed, extending the arrangement with new, more elongated foliage.

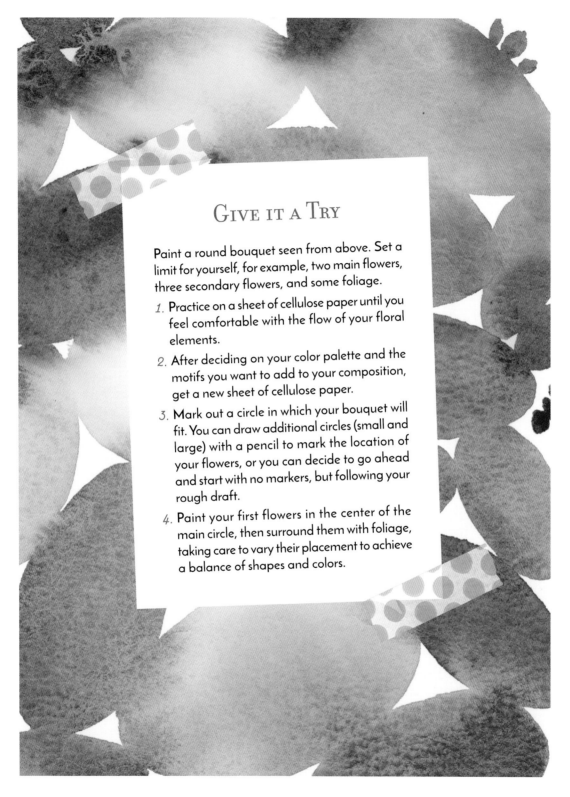

GIVE IT A TRY

Paint a round bouquet seen from above. Set a limit for yourself, for example, two main flowers, three secondary flowers, and some foliage.

1. Practice on a sheet of cellulose paper until you feel comfortable with the flow of your floral elements.

2. After deciding on your color palette and the motifs you want to add to your composition, get a new sheet of cellulose paper.

3. Mark out a circle in which your bouquet will fit. You can draw additional circles (small and large) with a pencil to mark the location of your flowers, or you can decide to go ahead and start with no markers, but following your rough draft.

4. Paint your first flowers in the center of the main circle, then surround them with foliage, taking care to vary their placement to achieve a balance of shapes and colors.

CREATING
A FLOWER GARDEN

I CHANGE THE SHAPE OF MY FLOWER ARRANGEMENTS ON A REGULAR BASIS TO AVOID GETTING BORED. FLOWER GARDENS ARE ONE OF MY FAVORITE COMPOSITIONS—I PLAY WITH OVERLAYS OR SIMPLY SWAP OUT ELEMENTS BETWEEN THEM. IT ONLY TAKES ONE NEW ELEMENT OR A DIFFERENT PALETTE TO MAKE ME FEEL LIKE I'M IN A WHOLE NEW GARDEN.

Creating movement

I prefer the name "flower garden" to "bouquet" for these arrangements because of the impression that the stems are coming out of the ground, whereas in a bouquet, the ends of the stems would be at different levels.

Your flower garden will only look natural if you manage to create the impression of movement. Once again, mastering the depiction of your subject is a matter of observation..

The difficult part is often in assembling the flowers, varying the contrasts, and, at the same time, keeping a coherent arrangement between stems and leaves. It's very easy to get tangled up! That's why I prefer to place the flowers first and then adjust the stems. After that, I position the leaves on the stems, trying to vary their orientation to create a little untidiness.

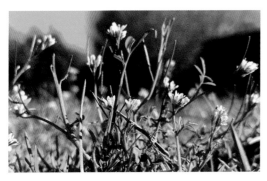

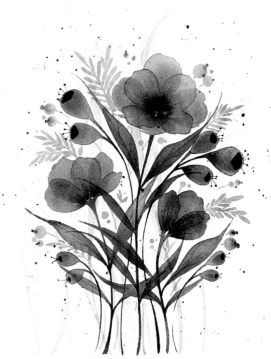

In the above picture, we can see that the stems are often untidy and don't grow in the same direction. It's important to vary the orientation of the flowers and foliage to achieve that natural look.

As with the bouquet seen from above in the previous step, I try to take a step back once all my elements have been assembled to get a better sense of any balance problems; it's easy to end up with a composition that's too full of elements.

A lush garden

When I started out, I was determined to make my little gardens as lush as possible. However, I quickly realized that adding too many diverse and complex elements didn't create the balance I was looking for. There were too many details and the whole thing became confusing. As a result, I gradually introduced the concept of layering in my gardens, with the aim of creating a sense of abundance in my foliage without adding too many elements. As with my bouquet seen from above, I chose to limit the number of flowers and foliage so my overall composition wouldn't get weighed down, while also keeping the overall lushness of the foliage.

Although painting transparent foliage is my favorite thing to do, I sometimes let myself be guided by a more spontaneous building of the garden without too much preparation. I follow the same approach as for my round bouquet, seen in lesson 14.

Step-by-step

EQUIPMENT

– A sheet of 300 gsm extra white cotton paper with a fine grain from the brand, Saunders Waterford

– Les Couleurs VF watercolor paints: Cornflower, Hydrangea, Bougainvillea, Bergamot, Physalis and Brocéliande

– A Dalbe Series 100 size 0 wash brush for the flowers and a Dalbe Series 520 R size 8 brush for the foliage

1. Select a color palette, primary and secondary flowers, and foliage in the same way as you did for the lesson 14 bouquet.

2. Trace the movement you want to give to your watercolor using a few light pencil lines, and then start to paint some untidy blades of grass that will act as a background.

2.

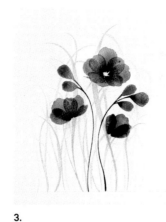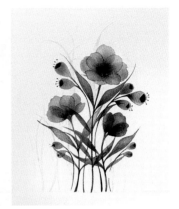

3.

3. Wait for the grass to dry, then arrange main and secondary flowers. Next, paint their stems and leaves, making sure to leave room for adding more foliage later on.

4. Build up the foliage between flowers, spread throughout the garden, taking care to vary colors and shapes.

TIP I like to add a few splashes to my flower arrangements for an added touch of artistry.

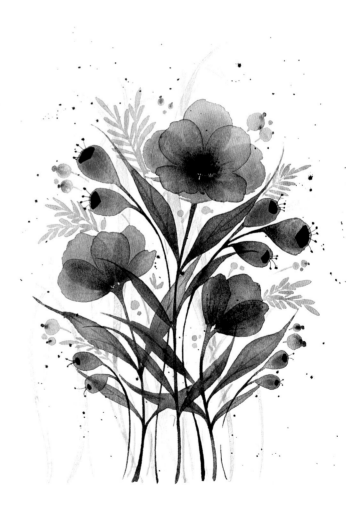

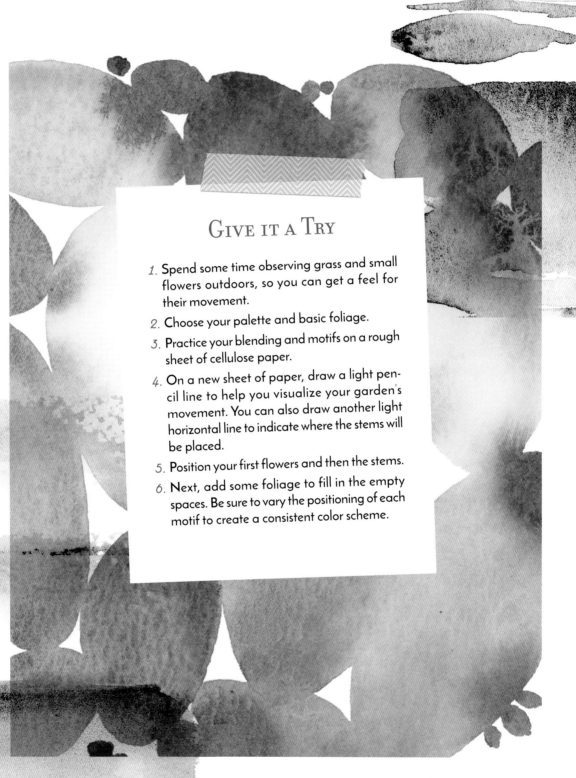

GIVE IT A TRY

1. Spend some time observing grass and small flowers outdoors, so you can get a feel for their movement.

2. Choose your palette and basic foliage.

3. Practice your blending and motifs on a rough sheet of cellulose paper.

4. On a new sheet of paper, draw a light pencil line to help you visualize your garden's movement. You can also draw another light horizontal line to indicate where the stems will be placed.

5. Position your first flowers and then the stems.

6. Next, add some foliage to fill in the empty spaces. Be sure to vary the positioning of each motif to create a consistent color scheme.

PAINTING OUTDOORS

SARAH VAN DER LINDEN

Tell me a bit about yourself.

I've always been creative, as far back as I can remember. As I grew up, though, the routine of everyday life, combined with the dullness of city life, stifled all my aspirations, so much so that at one point, I was no longer doing any activities that sparked my imagination. I had to leave the city and move to the countryside to find my creative soul and rediscover this world that had been lost to me. A tree leaf, a blade of grass, or a cloud has far more evocative power than any urban element. I started painting with watercolors soon after and my fascination for this medium has only increased over time.

I firmly believe that nature, inspiration, and imagination are intimately connected, and for me, one does not exist without the others. I'm an eternal optimist—I believe that it's never too late to learn something new and that the hardest part is taking the first step. That's why I launched my website in 2019, as a place for sharing Step-by-step watercolor ideas, as well as seasonal inspiration.

How did you get started with watercolors?

I started painting watercolors shortly after moving to the country a few years ago. My partner had bought himself a box of watercolors and seeing him experimenting with the colors made me want to try. I received a palette as a gift soon after and that was enough to spark a new passion! I was immediately attracted to landscapes, wanting to capture what

I saw in the countryside. There's something quite magical about the way the water interacts with the pigments, the way the colors diffuse, and the ease with which you can create something.

What inspires you most about watercolors?

I was immediately captivated by the fact that watercolors are easily transportable—the equipment is light and fits easily into a backpack. From the moment I realized this, the outside world became a huge playground! Inspiration is everywhere and watercolors make it easy to be creative anywhere, even if you only have a few moments.

I also like the fact that water is an ingredient in its own right and not just something you use to thin the paint. It can be used in so many different ways to create an environment that you never get tired of! Watercolors offer endless creative possibilities that gradually unfold.

What is your creative process?

All of my paintings are based on something I've seen in nature, whether it's in my garden or while out walking. Watercolors have truly taught me how to observe and be aware of my surroundings, no matter where I am. I also take a lot of photos of different textures and colors for reference—taking photos forces me to pay attention to details. I rarely use the pictures, but the process helps me remember what I liked. All these observations feed my imagination and allow me to be creative when I'm back at home. They are transformed into something that isn't "realistic," but inspired by reality. When I have a subject in front of me, like a flower for instance, I find it difficult to detach myself from it, but if I paint it from memory, I don't have any qualms about keeping only what I like!

What's it like painting outdoors?

Painting outdoors encourages you to take the time to discover a landscape, to become familiar with what makes it special, and, above all, to really look at it. This allows you to be anchored in the moment and disconnect from everything else. When I get to a new place, I sit down in silence and observe. I pay attention to colors and shapes, but also to sounds and smells. It's worth engaging all your senses. Hearing, touch, and smell are just as important as sight. For example, there's nothing better than being creative while listening to the birds sing! I don't grab my notebook and paint brushes until after I've spent a few minutes just observing. I love to capture an environment using just a few colors. I never paint a landscape exactly as it is, I just let myself be influenced by what's around me.

Can you give us some tips for painting outdoors?

I use the same equipment as when I'm at home, except that my color palette is more limited. I favor colors that allow for blending, but I've also added my favorite shades. Changing your location can be intimidating, and using familiar equipment allows you to get your bearings and not be in completely unfamiliar territory. I always carry something to sit on as well—like a tarp, for example—it's very useful if the ground is wet, and it allows me to set up anywhere!

No matter what your favorite subject is, everyone can find something to enjoy outdoors. You don't need to try to paint the whole scene and capture every detail. On the contrary, the aim is to keep only the most interesting elements. This could be a close-up of a flower silhouette or the mood of a landscape.

I think it's also important to realize that you won't be able to achieve the same result as when you're sitting at a desk. Painting on your knees, as I do, necessarily adds an element of randomness that's part of the process. The goal is to enjoy the experience and break away from your usual patterns!

Instagram: @mirglis
Website: mirglis.com

Banks of the Marne, July 2020

Massif de Chartreuse, June 2020

Ermenonville Forest, February 202

CREATING A
MONOCHROME WREATH

WREATHS ARE A VERY POPULAR COMPOSITION. THEY CAN BE USED
TO DECORATE A FRAME AND CAN ALSO CONTAIN A MESSAGE
IN THE CENTER, WHICH IS VERY POPULAR. WHETHER COMPLEX
OR SIMPLE, THEY'RE OFTEN USED FOR INVITATIONS AND CAN BE
CREATED IN AN INFINITE NUMBER OF WAYS TO SUIT ALL TASTES.

Monochrome

Personally, I prefer to paint wreaths in monochrome
and with very few details.

Painting in monochrome means choosing only
one color and using various shades of it. Choose a
color from your color wheel (see lesson 3) and match
it with adjacent colors to create a monochrome.

For my wreath of leaves, I wanted to explore as

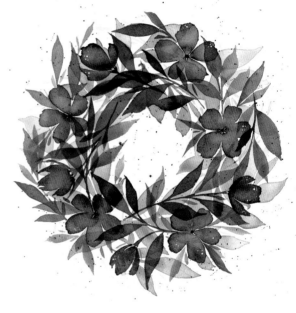

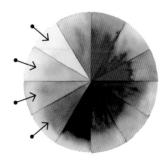

many variations of green as possible. Therefore, I
created several blends to bring warm and cool tones
to the whole (see lesson 3). I also wanted to intro-
duce as many contrasts as possible to explore the
different shades (see lesson 6).

Step-by-step

1. Cut your paper to obtain a square shape. Then,
locate the middle of the page and using a com-
pass, draw three circles: two to mark the area that
shouldn't be crossed into too much and a third, in
the middle of the first two, to maintain a guiding line
and to give a nice round shape to the wreath.

EQUIPMENT

– A sheet of Saunders
 Waterford 300 gsm
 extra-white, fine-grain
 paper

– Watercolor paints from
 the Bréhat range: Dark
 English Green, Dark
 Ultramarine Blue,
 Prussian Blue,
 Quinacridone Gold and
 Neutral Ink

– A Da Vinci Casaneo size
 2 brush

– A compass

1.

2.

3.

4.

2. Prepare your paints to get a clear idea of the actual colors you're going to use and make blends.

3. Trace out the first few leaves, trying to create blends between them, in a similar way to the pebble blending exercise in lesson 5.

4. Between each leaf, either rinse your brush a little to thin the color, accentuate it using pure pigments from the pan, or alternatively, use a color that you've blended in one of the wells.

5. Try to vary the orientation of the leaves in order to create a sophisticated and elegant disorder.

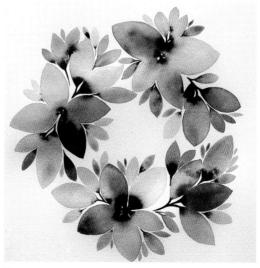

5.

6. Finally, add details, like leaves or circles, to balance the shape of the wreath and fill in some of the blanks.

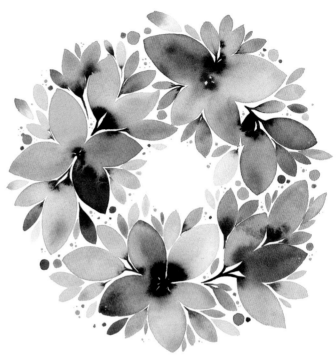

GIVE IT A TRY

Paint your own monochrome wreath.

1. Choose a base color from which you will create different shades. If necessary, use the color wheel for your colors and then make your blends.

2. Outline the shape you want for your wreath by drawing circles with different spacing.

3. Arrange your leaves a little at a time, as in step 5. Vary the contrasts by experimenting with colors and blends, as well as with the shapes of your leaves.

CREATING A
NEGATIVE PAINTING

THE MOST COMMON WATERCOLOR TECHNIQUE IS THAT OF
LAYERING, FROM THE LIGHTEST TO THE DARKEST SHADES. THIS MAKES THE
FOREGROUND COLORS MORE INTENSE—TO CREATE DEPTH IN A LANDSCAPE,
FOR EXAMPLE. ON THE OTHER HAND, IF YOU WANT YOUR FOREGROUND TO BE
LIGHTER THAN THE BACKGROUND, YOU CAN TRY THE "NEGATIVE" TECHNIQUE.

How does it work?

Watercolors painted in negative are very pleasing to the eye. The impression of depth achieved through this use of light is mesmerizing.

The technique involves layering the levels in reverse: instead of painting the most distant level first (the background), you start by painting the foreground.

The edges of the elements you want to leave lighter should be protected by emphasizing them in the next level's color. This way, the foreground will be clearer than the second level, which in turn will be clearer than the third level, and so on.

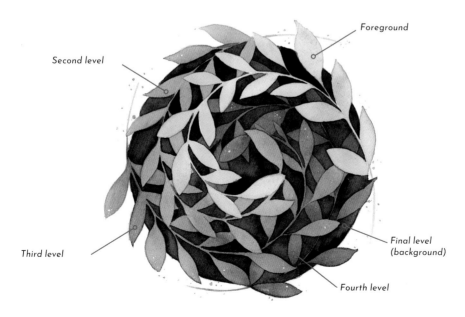

Foreground

Second level

Third level

Fourth level

Final level
(background)

EQUIPMENT

- A sheet of Arches 300 gsm fine-grain cotton paper in 8" x 8" format

- A Derwent electric eraser

- Watercolor paints in Prussian Blue, Dark English Green, Quinacridone Gold, Dark Ultramarine Blue and Neutral Ink from the Bréhat range, and Cobalt Green and Perylene Green from Winsor & Newton

- A Da Vinci Casaneo size 0 brush and a Dalbe 520 R size 4 flat brush

- Masking tape

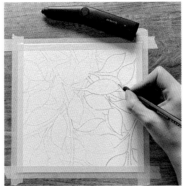

1.

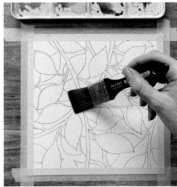

2.

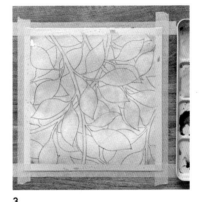

3.

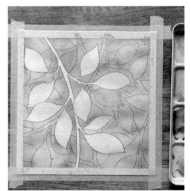

4.

Step-by-step

1. Apply masking tape to all four edges of the paper to secure it, then sketch out your picture. To remove any misplaced lines, I use a very precise electric eraser made by Derwent. When I'm happy with the positioning of my foliage, I accentuate my pencil strokes using a 2B pencil, so they will stay visible after several layers of paint.

2. Using a flat brush, spread a layer of water over the entire sheet. This helps manage the drying process and to get better blends.

3. Apply a first layer of very transparent watercolor pigments. This first layer is also called a wash, which forms the foreground of the watercolor.

4. Begin to build the second layer by contouring each of the elements in the foreground with darker pigments.

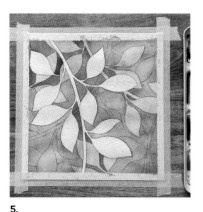

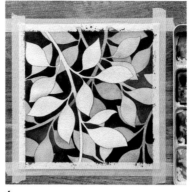

5.

6.

TIP I remove the masking tape very carefully so as not to tear my paper. Some papers are more resistant than others to this kind of operation.

5. When the paint is dry, work on the third level. This time, the paint shouldn't touch the foreground or background.

6. The final level forms the background of the watercolor and highlights the third level.

GIVE IT A TRY

Paint a negative watercolor.

1. Select a paper size, then apply strips of masking tape to all four edges of the paper.

2. Start with only three levels. Draw just two "tiers" of motifs. Make the motifs quite large so you don't get lost in the details.

3. Apply your first layer of very transparent watercolor paint over the entire page. Leave it to dry.

4. Apply the second, darker layer, taking care not to get any paint on the foreground elements.

5. Finally, add your third and final layer of very dark paint, which will highlight your second level.

6. When everything is very dry, gently peel off the masking tape.

CREATING
AN HERBARIUM

NATURE IS AN INEXHAUSTIBLE SOURCE OF INSPIRATION AND WE LEARN
A LOT BY OBSERVING IT. THE WAY PLANTS' COLORS CHANGE WITH THE
SEASONS IS FASCINATING, PARTICULARLY THE LEAVES ON THE TREES AND
BUSHES. PAINTING LEAVES IS SOMETHING I FIND EXTREMELY
RELAXING, AS THE BRUSH MOVEMENTS ARE ALMOST INTUITIVE
AND IT'S EASY TO INTRODUCE LOVELY COLOR VARIATIONS.

Cuttings

When I see pretty foliage on my walks, I usually
pick some and then dry it at home. I carefully save
all these little treasures because they allow me to
approach new watercolors using real elements and
to visualize them better.

Leaves are foliage that's very easy to dry and store.
For this reason, I was inspired to make a leaf herbarium using the cuttings I've collected recently.

Photo of a bush taken in the fall.

Step-by-step

1. On a square sheet of paper, draw a circle with a
compass to outline the shape of my composition. Assemble the leaves (dried and fresh) in the center of
the circle to preview the composition and take a photo so you don't forget it. Make sure to vary the colors,
shapes, and sizes of the leaves to add contrast.

EQUIPMENT

- A sheet of Arches 300 gsm fine-grain cotton paper in 8" x 8" format

- A Derwent electric eraser

- Watercolor paints in Prussian Blue, Dark English Green,

- Quinacridone Gold, Dark Ultramarine Blue and Neutral Ink from the Bréhat range, and Cobalt Green and Perylene Green from Winsor & Newton

- A Da Vinci Casaneo size 0 brush and a Dalbe 520 R size 4 flat brush

- Masking tape

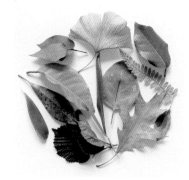

1.

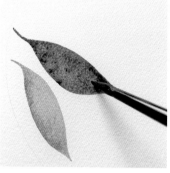

2.

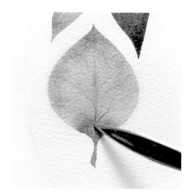

3.

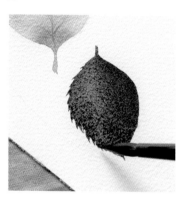

2. Using a round brush with a pointed tip, trace out the first leaves and, in the still wet watercolor, add shades and color variations to give the leaves substance.

3. Vary the positioning of the leaves to add some contrast to the composition. Add details to the leaves to lend each one a personal touch. For example, use a pointed letter opener to make grooves in the still wet watercolor.

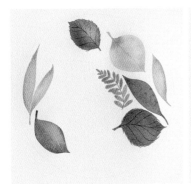 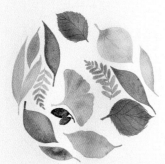 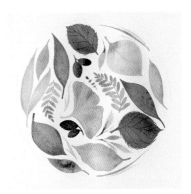

4.

4. Adjust the sizes of the leaves according to the space you need to fill so each leaf fits in with the others, and if necessary, add extra details and little imaginary leaves to fill the gaps.

5. Finally, put some finishing touches on the perfectly dry leaves by adding grooves using a fine brush or a gel ink pen.

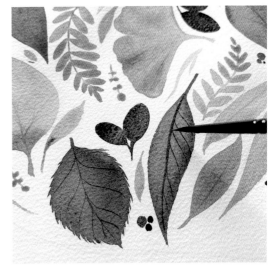

5.

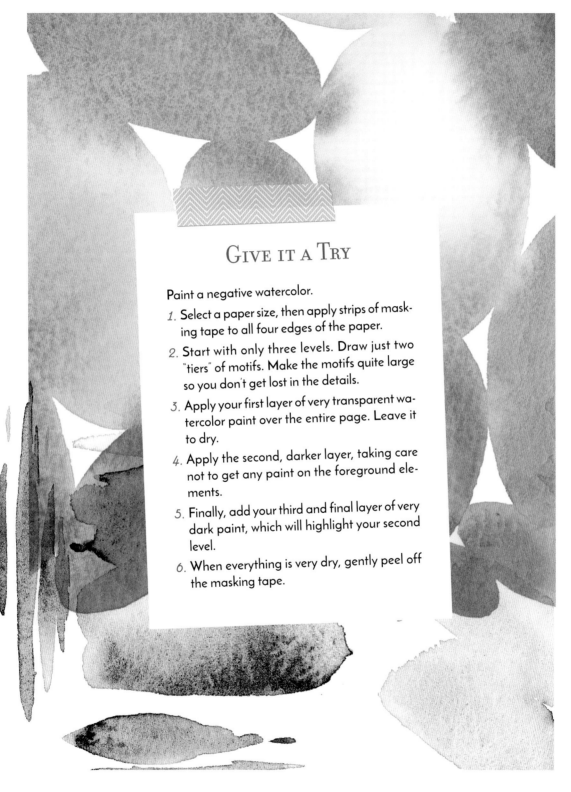

Give it a Try

Paint a negative watercolor.

1. Select a paper size, then apply strips of masking tape to all four edges of the paper.

2. Start with only three levels. Draw just two "tiers" of motifs. Make the motifs quite large so you don't get lost in the details.

3. Apply your first layer of very transparent watercolor paint over the entire page. Leave it to dry.

4. Apply the second, darker layer, taking care not to get any paint on the foreground elements.

5. Finally, add your third and final layer of very dark paint, which will highlight your second level.

6. When everything is very dry, gently peel off the masking tape.

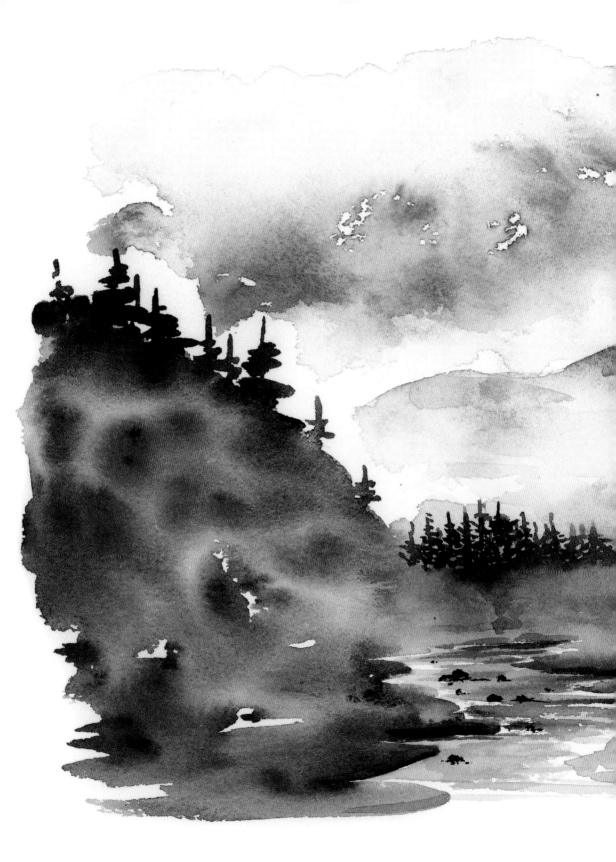

AN INTRODUCTION TO LANDSCAPES

This section focuses on painting watercolor landscapes using reference photos. The technique I use most often is layering, but I also like to explore other techniques to broaden my skills. Painting landscapes involves learning to observe the natural world through a photo or real-life situation and preparing well to gain greater fluidity in your movements when tackling a painting. This will allow you to avoid some of the pitfalls, such as not having anticipated which areas should remain blank or ending up with elements that you can't fit into the picture.

ANALYZING
A PICTURE

PERSONALLY, I'M MORE COMFORTABLE PAINTING MY LANDSCAPES
BASED ON A REFERENCE PHOTO. I LIKE TO BE ABLE TO TAKE MY
TIME ANALYZING AND PREPARING THEM. ON THE OTHER HAND,
ALTHOUGH PAINTING OUTDOORS BRINGS WITH IT CERTAIN
RESTRICTIONS, IT'S ALSO, IN MY OPINION, MORE INSTRUCTIVE.

Analyzing

Before starting to paint a landscape, I always go
through a process of analyzing the reference image.
I first try to determine the number of levels in the
landscape, which will help me get ready between
each drying phase. I then try to identify the colors
I will use, particularly those for the background. If
necessary, I do some blending and experiment on a
scrap piece of paper.

At the same time, I always try to determine where
the light is coming from and how the landscape is lit.
This is an essential detail for preparing the areas that
will remain blank. Finally, if the image is complex, I
identify which elements in my reference image I can
possibly remove. Some details may be redundant,
and adding them only adds to the overall weight of
a painting.

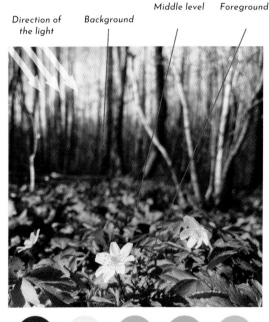

Direction of the light *Background* *Middle level* *Foreground*

Color palette made using the Coolors app

Neutral Ink (Bréhat) *Helios Purple + very diluted Ultramarine Blue (Bréhat)* *Olive Green (Bréhat)* *Orange (Dalbe) + very diluted Van Dyck Brown (Bréhat)* *Diluted Ultramarine Blue (Bréhat)*

Differentiating the levels

In a landscape, you can differentiate a number of levels in order to create perspective and depth.

Background

This is the most distant level in your image. It represents the background and the sky. The colors here are generally light and the details imperceptible in order to develop the feeling of distance. It allows you to lay down the first colors, create a mood and lay the first foundations that will determine the location of your elements by means of the horizon line. Painting it requires a certain amount of speed, as you have to work the colors on wet paper to create a blurred background. Sometimes, it may be necessary to moisten the entire sheet again in order to embellish the background with new colors or details.

Middle level

The details gradually begin to emerge more clearly. The colors become more and more vivid and contrasted. When painting your middle level, it's important to identify the horizon line, as this is your landscape's axis, and it will guide you as you create perspective for the levels.

Foreground

The colors are very contrasted and saturated, so that they contrast with the background and the middle level. The level of detail is very well developed, and it's easy to distinguish all the elements that comprise it. The foreground must give the impression of being on the same level as us.

TIP Adding a new coat of paint doesn't necessarily mean that you're changing levels. Indeed, it's sometimes necessary to add several layers of detail to a single level. For example, building up a dense forest full of trees and foliage will probably require several layers of paint per level.

Horizon line

The horizon line is actually the line on which your eye rests when looking at a landscape. In most cases, it marks the boundary between sky and land. The first elements that will form the middle level are often placed there.

Different techniques

Painting with watercolors offers something for everyone. From abstract to ultra-realistic landscapes, everyone has their own way of interpreting it and that's what makes this medium so magical for me. Don't miss my interview with Maria Smirnova (aka Magrish), a watercolor artist whose way of interpreting landscapes is breathtaking (see page 95).

Depending on how you want your landscapes to look, you may need to work more on wet-on-wet or wet-on-dry.

Wet-on-wet

To achieve a color-blended landscape, I use the wet-on-wet technique, which involves applying watercolors to wet paper. By doing this, the pigments are dispersed in the water that's on the paper.

Here, the difficulty is managing how the paper dries. Indeed, if the paper is too wet, the blending may be too intense for what you want to achieve. Conversely, if the paper dries too quickly, it's likely to cause too many halos.

Halos are unsightly if the goal is creating a clean, unified background (i.e., a cloudless sunset). On the other hand, if your goal is creating a cloudy sky, halos are an effect you may want to intentionally pursue. In this case, you can add water to paper that's just about dry to create an effect where the pigments repel each other and the white of the paper reappears.

Wet-on-dry

If I want to create a realistic and accurate landscape, I tend to use the wet-on-dry technique, which means I wait for my paper to dry completely before adding new elements.

GIVE IT A TRY

Now it's your turn to analyze a landscape in a photo.
1. Choose a landscape and take a few moments to look at it closely.
2. Next, consider the following points: Where is the light coming from? Where are the shaded areas? Where is the horizon line? Where are the different levels? What are the dominant colors? What is the atmosphere or mood generated by the landscape?

INTERPRETING LANDSCAPES

MARIA SMIRNOVA

Tell me a bit about yourself.

My name is Maria Smirnova. I'm a Russian water-colorist currently living in France.

I used to be an electrical engineer, but I changed careers to pursue my dreams. I've been passionate about art since I was a child, and drew and paint-ed as a hobby for a long time. Several years ago, I decided to move to Paris to begin my creative journey as an artist.

Today, I'm a professional watercolorist, and I also teach watercolor classes for beginners, blog on Instagram, create short videos, and participate in various contests and exhibitions. I continue to learn new things on a daily basis, and I'm also studying contemporary art at university.

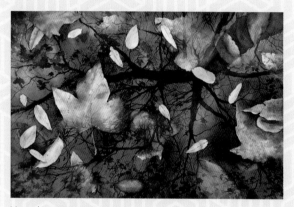

November, 2019, 56 × 38 cm

How did you get started with watercolors?

I first intentionally tried watercolor painting at the studio where I was learning academic drawing. To be honest, I didn't like it at all. I started with very basic materials on a sheet of vertically oriented cellulose paper and painted a still life. This experience made me forget about watercolors for several years, until one day a friend of mine asked me to paint a boat for him. I searched the internet for inspiration and references and discovered some watercolors—some of them depicting water—painted using modern techniques. I was amazed at how different they were from what I had done in my first attempts. So, I began learning the technique and haven't stopped since.

November, 2019, 22 x 15 inches

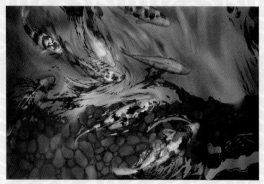

What do you like most about watercolors?

I love the transparent aspect of the medium and the fact that I can't keep adding and correcting a painting indefinitely, as is the case with oils, for example. There always comes a point when, technically, I have to stop.

It's also a very controversial technique. I've learned to paint much faster with watercolors, but it can also take me hours to complete a painting. I'm used to thinking and planning things before I start, but at the same time, it's a very spontaneous and intuitive process. It's not boring and I like that!

Can you tell me a bit about your creative process?

I do three types of paintings. The first type comes from impressions, from something I saw in real life and that I want to bring to life in paint. This is how most of my landscapes come about. They're essentially quick pieces, made during a single painting session.

The second one comes from inside me, from a concrete idea. This can be a very long process. I do preliminary sketches and trials, reflect, look for references, and sometimes just wait until I'm in a good emotional state. I also try out new equipment and experiment with mixed media for these types of pieces.

The third one is actually a combination of the first two, where I find ideas in my photos and freely transform them into my paintings.

The common link between these three different processes is that I sometimes spend more than an hour thinking, listening to music, and getting ready at my workbench before I start painting.

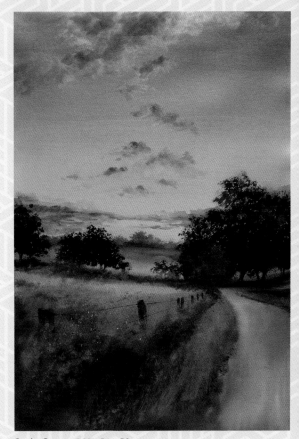

On the Camino, *2019, 56 × 38 cm*

Adding the final details to the picture can also take hours. I enjoy the creative process and all these steps are important.

What advice would you give to help someone improve their skill with this medium?

Progress = (20% knowledge + 80% practice) x love.

Instagram: @magrish
Website: mariasmirnova.art

PAINTING
A DENSE FOREST

IN THIS LESSON, I'LL SHOW YOU HOW TO PAINT A DENSE FOREST
LANDSCAPE USING WET-ON-DRY AND PAINT LAYERING TECHNIQUES.

Layering

The wet-on-dry technique allows us to be more precise, as well as improving the way we build perspective. As the layers of paint are overlaid, the whole thing becomes more intense in color and dense in detail.

However, this technique requires patience, as the paper must be perfectly dry before you can apply a new layer of paint.

TIP I prefer to paint landscapes in relatively small formats (this forest is done on a 7" x 7" sheet) because this allows me to manage the drying process better and build up the elements easily. The more you improve in this aspect, the more confident you will be when working on larger formats.

Step-by-step

EQUIPMENT

– A sheet of 300 gsm fine-grain cotton paper from Dalbe

– Watercolor paints in Paynes Gray and Neutral Ink from the Bréhat range, and Quinacridone Burnt Orange and Permanent Brown from Daniel Smith

– A Da Vinci Casaneo 5098 size 30 flat brush, an Action fan brush, and two round brushes —a Da Vinci Casaneo 498 size 2 and a Dalbe 200 series size 6

– Making tape

– A tissue

1. Mark out your painting area using masking tape, then sketch across the horizon line. (I might also lightly sketch the trees in the foreground as a reference point.)

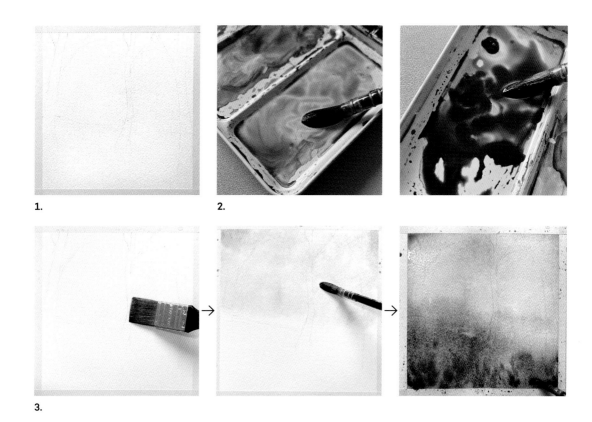

1.

2.

3.

2. Prepare your first blends using Paynes Gray and Neutral Ink for the sky, and a second blend of very dark orange using Neutral Ink, Quinacridone Burnt Orange, and Permanent Brown for the ground.

3. Wet the paper using a flat brush to work the background wet-on-wet. Apply Paynes Gray blend for the sky up to the horizon line, then the orange color for the ground.

4. Return to the sky and add the shape of the leaves that form the background. To do this, use a fan brush and lightly tap it on the paper.

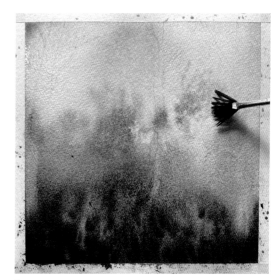

4.

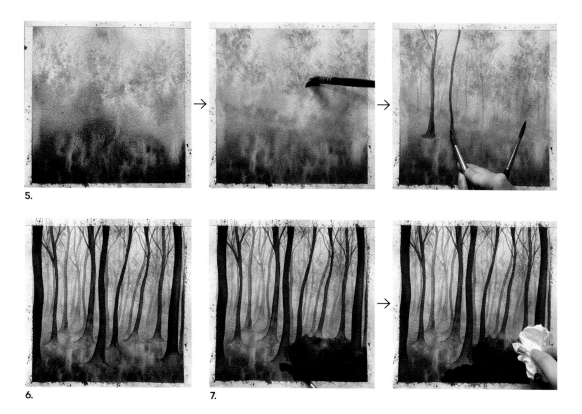

5.

6.

7.

5. When the paper is dry, form the shapes of trees in the distance and more leaves. Next, trace out the first trunks. Blend the bottom of the trunks into the ground using a second clean, slightly wet brush.

6. After waiting for the paper to dry again, add new layers of trees until you get the density you want for the forest.

7. Turn your attention to the ground. Using a tissue, tap the still wet watercolors to remove some pigments and create a foamy textured effect, then fill in some details to give depth.

8. Finally, add texture and depth to the trunks using white gouache or by intensifying the color on the trunk edges.

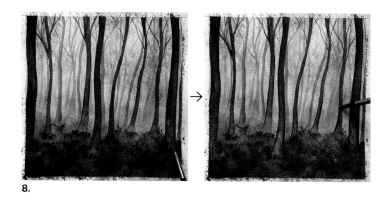

8.

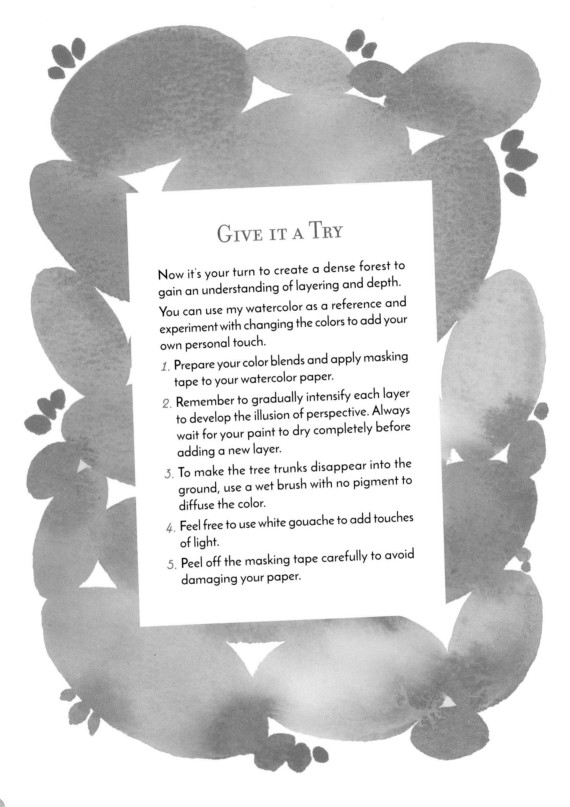

Give it a Try

Now it's your turn to create a dense forest to gain an understanding of layering and depth.

You can use my watercolor as a reference and experiment with changing the colors to add your own personal touch.

1. Prepare your color blends and apply masking tape to your watercolor paper.

2. Remember to gradually intensify each layer to develop the illusion of perspective. Always wait for your paint to dry completely before adding a new layer.

3. To make the tree trunks disappear into the ground, use a wet brush with no pigment to diffuse the color.

4. Feel free to use white gouache to add touches of light.

5. Peel off the masking tape carefully to avoid damaging your paper.

USING THE WET-ON-WET
TECHNIQUE FOR A LANDSCAPE

I THINK THIS IS A MORE DIFFICULT TECHNIQUE THAN THE PREVIOUS ONE BECAUSE IT REQUIRES YOU TO MOVE QUICKLY WITH EACH ELEMENT IN THE PAINTING. YOU ALSO NEED TO MANAGE THE AMOUNT OF WATER PROPERLY TO PREVENT THE PIGMENTS FROM GOING IN THE WRONG DIRECTION.

Working on wet paper

We call this technique "wet-on-wet," meaning that you work with the watercolors on wet paper. It's ideal for creating blurred effects in a painting to add perspective to elements in the distance. The challenge here is mastering blending. If the paper is too wet, it will diffuse the pigments too much, while if the paper has dried too much, it won't diffuse the pigments enough. You will need to keep an eye on your paper and monitor its shine, which will tell you how wet it is. This control of the drying process improves with practice. If your paper is too dry, I recommend stopping and letting it dry completely before continuing to avoid smudging (if this isn't the effect you are looking for).

Also, be aware that adding water to watercolors while they are still wet will help repel the pigments. I often use this effect to create clouds, for example, then remove the excess water and pigment with a dry brush to restore the white of the paper. I would recommend using fine-grain or torchon cotton paper when working wet-on-wet, as it will absorb the water more slowly.

Be sure to apply masking tape to all four sides of your paper to keep it in place and prevent it from curling.

Step-by-step

EQUIPMENT

- 300 gsm fine-grain cotton paper

- Watercolor paints in Paynes Gray, Quinacridone Gold and Neutral Ink from the Bréhat range, Tundra Violet from Schmincke, and Umber Violet, Quinacridone Burnt Orange and Perylene Green from Daniel Smith

- Two Da Vinci Casaneo 498 round brushes in sizes 0 and 2 and a Da Vinci Casaneo 5098 flat brush

- A tissue for texture effects

- Masking tape

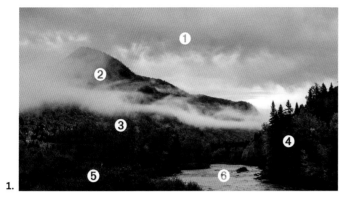

1. Sky
2. Mountain
3. Trees underneath the mountain
4. Hill on the right
5. Grass in the foreground
6. River

1.

When painting the landscape in this lesson, I worked on each level one after the other. I drew a visual path before I started painting, so that each level would fit together properly.

1. Start by analyzing your reference photo. Map out the path you'll follow as you paint the different elements in the landscape.

2. Once you've found your path, prepare the paper by applying masking tape to all four sides. Trace out some markers by outlining the shapes in the landscape.

3. Prepare your blends in the wells on your watercolor palette.

4. Wet the paper using a flat brush, in order to achieve good blending and be less worried about managing how the colors dry.

5. Apply your first pigments using violet shades to reproduce the color of the clouds. Using a tissue, remove some pigments to add texture to the clouds.

2.

4.

5.

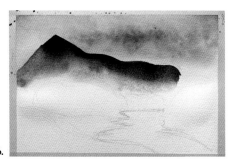

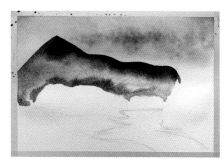

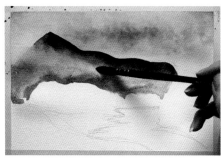

6.

6. When the sky is dry, paint the mountain and the trees below it using gradations of color. With a clean, wet brush, create clouds over the mountain by removing some of the still wet pigments from the paper.

7. Next, paint the hill on the right side and create shades of color reminiscent of foliage.

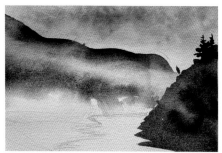

7.

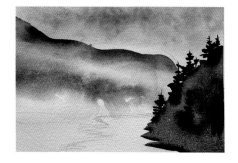

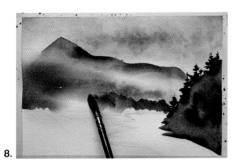

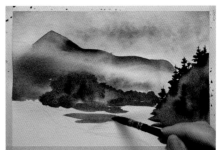

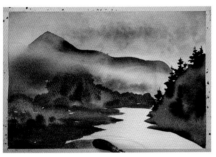

8.

8. Continue on the left, making the trees below the mountain orange and adding the grass that's in the foreground.

9. Wait for the watercolors to dry before applying a second coat of paint to enhance the contrast of the trees underneath the mountain.

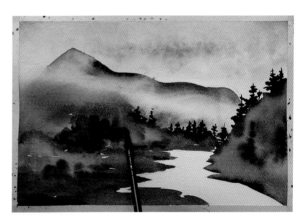

9.

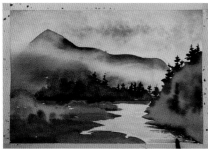

10.

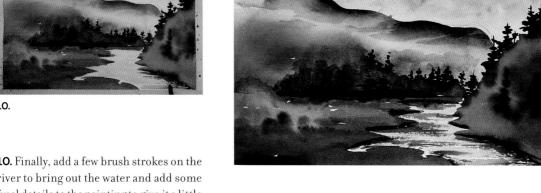

10. Finally, add a few brush strokes on the river to bring out the water and add some final details to the painting to give it a little more depth.

GIVE IT A TRY

Now it's your turn to create a landscape using the wet-on-wet technique.

1. Before you begin your painting, complete the analysis phase and envision the path you will take.

2. Follow the tutorial to get started on your painting. The shapes don't need to be precise, as we're working here on blending and color management. Getting the pigments to the right places requires an understanding of how to manipulate the different drying phases.

3. Once the paper is dry and the colors are set, you can add new layers of paint to bring movement and detail to your watercolor.

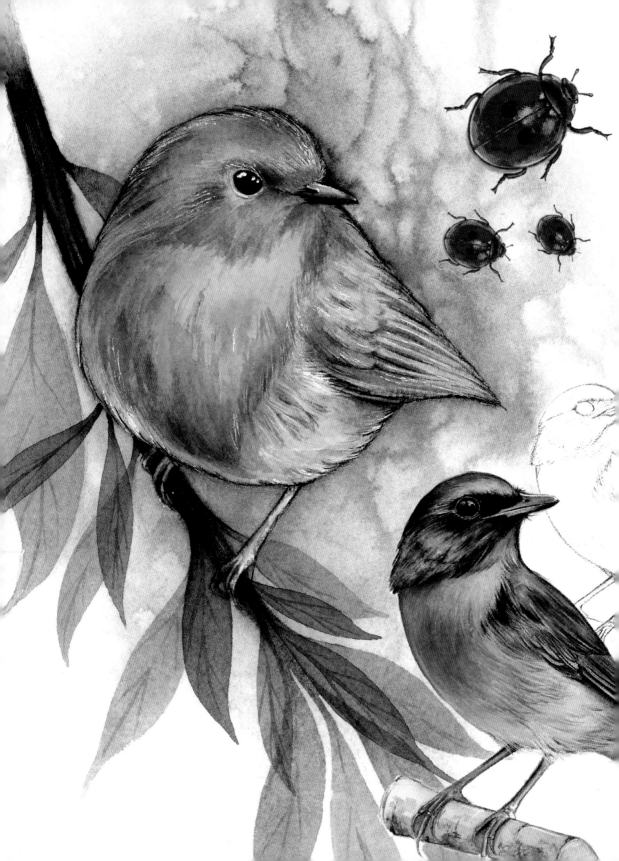

REALISM
WITH WATERCOLORS

In this section, we will explore how the play of light and shadow can bring your artwork to life. Whether it's a still life or a living subject, you'll discover how adding just a few details can change the final result. We will also take a look at the multitude of colors that are hidden in a subject and how to reproduce and work with them.

OBSERVATION

IN EXACTLY THE SAME WAY AS YOU DID WITH AN IMAGE OF A LANDSCAPE
IN LESSON 19, TAKE A MOMENT TO OBSERVE AN OBJECT THAT'S NEARBY.
LOOK AT WHERE THE LIGHT IS COMING FROM, AND HOW SHADOWS AND
TEXTURES PLAY IMPORTANT ROLES IN SHAPING YOUR SUBJECT.

Depth and texture

As you study your subject, you will probably notice that the depth directed towards your light source appears almost white, while the opposite depth (the shade) is very dark.

Now imagine this object in black and white. Even when there's no color, you can identify the subject's material by its characteristic texture, such as the grain of wood, the shine of plastic or metal, the rough texture of a stone, or the softness of a fabric.

Here we can guess what materials this brush is made of without even seeing its color through the shine of the metal, the texture of the wood, and the soft look of the fibers.

Drawing a sketch

Drawing a sketch helps you become more familiar with your subject. However, you don't need to make a perfect copy of your model, just practice getting realistic proportions.

As you practice drawing, your eye will be trained to visualize the curves and angles that play important roles in the structure of your subject. Elements are articulated together and you'll get more and more used to comparing them to find the right proportions. By adding a few shadows, you'll eventually achieve the depth needed to properly depict your subject.

When copying my subjects, I always start by identifying one element in my model that I can compare to all the other elements and use as a visual gauge. I sometimes use the scale on my ruler for more precise reference points.

When I draw my sketch, I make rough strokes using an HB pencil, which I sharpen as I go along using a B or 2B pencil. Be aware that you'll have more difficulty working with textures if your design is very small.

Hidden colors

You may not realize it, but everything around us has hundreds, even thousands, of different color shades. To find these "hidden colors," you must learn to look beyond the color in front of you.

Let's take this mushroom for example: how many colors do you see?

The colors you may identify first are probably shades of brown and beige. But take a closer look…

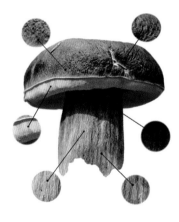

The cap of the mushroom is illuminated by a cold light and I see purplish and bluish hues. The middle of the cap has shades of brown tending towards red, and the bottom colors tend more towards shades of orange and yellow.

- The white of the cap isn't really white; it's rather greenish, off-white, and gray in the shaded part.

- The stem is composed of two parts. The upper one is shaded and has very dark shades of olive green, mixed with the colors of the lower part of the stem, composed of brown, orange, and green.

- Depending on when the picture is taken, this mushroom will have different shades of color. The seasons, weather, and time of day play an essential role in the surrounding colors, which are also reflected in your subject.

Learning how to observe colors properly is essential, therefore, if you want to paint an element realistically.

GIVE IT A TRY

Look around for small subjects that you can easily copy in pencil.

1. Do the observation exercise and ask yourself: what makes this object look real?

2. Sketch your subject and mark the shaded areas with slight hatching.

3. Practice on several objects, if needed.

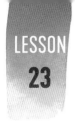

ADDING
REALISM

AS I'M SURE YOU'VE NOW REALIZED, CONTRASTS, TEXTURES,
DEPTH, AND COLORS ARE IMPORTANT ELEMENTS IN BRINGING YOUR
WATERCOLORS TO LIFE. CONTINUING ON FROM OUR EXPLORATION
OF OBSERVATION TECHNIQUES, THIS LESSON WILL INTRODUCE
YOU TO THE BASICS OF ADDING DEPTH TO YOUR PIECES.

Layering

Layering pigments allows you to progressively accentuate your colors and gain more control over the shapes you want to achieve.

Much like building the levels in a landscape, it's a matter of refining the features and details little by little, layer by layer. Contrasts are accentuated and colors become more intense, creating depth.

Adapting to your ability

Creating realism with watercolors is technically difficult. It requires some mastery of all the techniques, in addition to the detailed building up of your pictures. If you're new to watercolors, I recommend you set yourself progressive steps so you don't get discouraged by the various obstacles you will encounter.

For example, start by painting small, simple subjects to become familiar with all the technical aspects of realistic painting: the precision of details such as hairs and textures, the building of shading and depth, the handling of colors and water management, etc.

As you get the hang of all these techniques, you'll be able to set new goals for yourself and build on your breakthroughs; for example, if you've mastered painting a bird on a branch, try doing one in flight next!

Step-by-step

A ball

Painting a ball is a visually meaningful exercise that allows you to see how placing a color in a particular spot can change your picture's whole perspective.

Once again, you'll also see that there's no shadow without light and perspective is lost.

EQUIPMENT

– A sheet of Arches
 300 gsm fine-grain
 cotton paper

– Watercolor paint in
 Paynes Gray from the
 Bréhat range

– Two Da Vinci Casaneo
 498 size 0 round brushes
 (one to apply the color,
 the other diffusing it with
 water)

– A compass

1.

2.

3.

1. Draw a circle on the paper using a compass, then indicate the direction of the light with an arrow.

2. Mix the Paynes Gray with plenty of water. Apply it to the opposite side of the light point and gradually diffuse the color using a clean, wet brush.

3. Apply a second layer of Paynes Gray, then a third, this time very dark, while still leaving a light area. Diffuse the color once again.

4. The ball is now resting on the ground. So, to create this illusion, paint a shadow underneath it, away from the light. To depict a bright floor, use white gouache to create a small reflection on the bottom of my ball.

4.

A glass of water

Painting a glass of water is a good idea, technically speaking, because it allows you to work not only with curved and hollow shapes, but also to play around with the transparency of the water and the glass.

1.

2.

3.

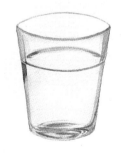

4.

1. Sketch the glass first and to ensure that the proportions are symmetrical, make three vertical and two horizontal lines. These are my reference points for drawing my glass. I then draw three oval shapes around the middle lines to indicate the curvature of the glass.

2. Using a kneaded eraser, remove the reference marks and blur the lines of the glass by lightly tapping the eraser over the lines.

3. Apply a first wash of very diluted Paynes Gray along the curved part of the glass and while still wet, apply a few touches of slightly darker gray on the outer parts, i.e., the edges and bottom of the glass.

4. Once the paper is dry, accentuate the edges of the glass to give an impression of thickness, as well as the places where the water settles.

5. Accentuate the lines again with a more concentrated paint.

6. Finally, apply thinned out Paynes Gray to all the areas of depth on the glass to accentuate the curves. Using a little white gouache, create highlights and shiny areas. Add the glass' shadow on the ground using thinned out Paynes Gray.

TIP To improve your drawing technique, I would suggest that you draw a little each day, copying various objects from your daily life. Whichever you choose, simply practicing regularly will help you improve your understanding of space and form.

5.

6.

GIVE IT A TRY

Try the ball exercise to become familiar with how to create a three-dimensional object.

You can also work on the movements involved in diffusing a color. Apply a dark color in one corner of your circle and with a clean, wet brush, diffuse the pigments to a wider area until they disappear.

Practice with simple objects around you and as you progress, add complexity.

PAINTING
A MUSHROOM

LET'S MOVE ON TO PAINTING A SLIGHTLY MORE COMPLEX
SUBJECT. I CHOSE A MUSHROOM BECAUSE IT HAS SEVERAL
FEATURES THAT I FIND INTERESTING TO WORK WITH BECAUSE
OF THE MANY SUBSTANCES AND COLORS THAT MAKE IT UP.

Painting plants

Having grown up in a cottage on the edge of the woods, I'm naturally attracted to the forest environment and related subjects. Mushrooms are a subject that I particularly like because they bring back fond childhood memories. I find it easier to sketch an element from the plant world than a human or animal portrait, as we're generally less concerned with how closely it resembles the model. However, the challenge here is successfully capturing all the nuances of color in our subject, the mushroom, and bringing it to life.

The color tones will change depending on whether it's in the shade or in the light, so you need to know how to play with all the shades in your palette. What I enjoy most about painting plants is working on the textures and small flaws in my subjects, which give a realistic effect.

The reference photo on the left and my watercolor on the right.

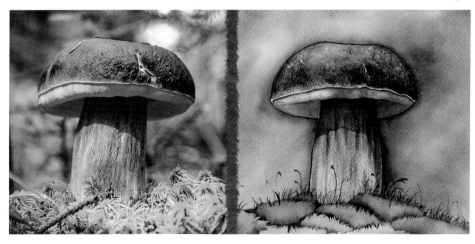

EQUIPMENT

- HB and 2B pencils

- An eraser with a very fine tip and a kneaded eraser

- A sheet of Arches 300 gsm fine-grain cotton watercolor paper

- Watercolors: Permanent Brown (Daniel Smith), Quinacridone Gold, Ultramarine Blue and Helios Purple (Bréhat) for the mushroom cap; Ocher and Paynes Gray (Bréhat) for the underside of the cap; Ocher, Brown, Paynes Gray and Orange (Bréhat) for the stem; Olive Green (Bréhat) for the top of the stem; and Gold Green and Perylene Green (Winsor & Newton) for the bottom and grass

- White gouache

- Two round brushes, one precise and one softer for diffusing the color

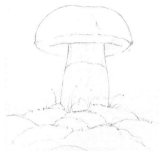

1.

2.

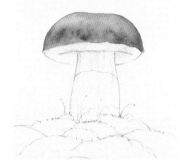

3.

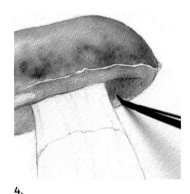

4.

Step-by-step

This mushroom not only looks delicious to eat, it's also a great vehicle for learning how to create the textures that will give it realism. On the cap and underneath, and at the top and bottom of the stem, several variations of textures combine warm and cold colors, making this subject such an interesting one to work with.

1. On the watercolor paper, try to follow the model and draw a rough sketch of the mushroom using an HB pencil. Go back over the lines to refine the shape of the mushroom, creating emphasis using a 2B pencil.

2. In the wells on your watercolor palette, prepare the first color blends for the mushroom.

3. On the top of the cap, I put the first violet shades. Gradually, I change the color to add shades of brown, red, and Quinacridone Gold.

4. Using ocher and Paynes Gray, build up the color on the underside of the cap. Accentuate the hollow parts with Paynes Gray.

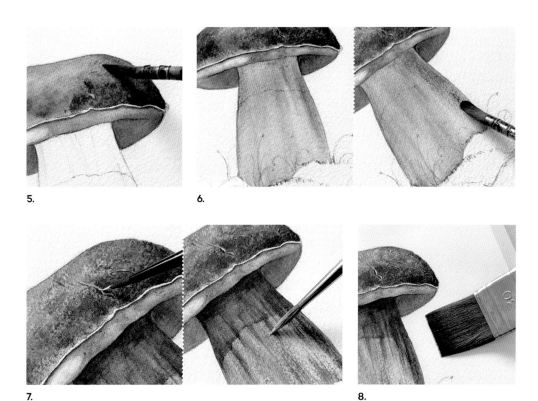

5. 6.

7. 8.

5. Wipe your soft brush on a cloth to remove as much water as possible. Then, pick up some dark red pigments that are left in your well. Place the thick tufted part of your brush onto the mushroom cap and rub it around. This technique creates a grainy texture, thanks to the grain on my paper.

6. Using a blend of brown, Paynes Gray, and orange, build up the stem of the mushroom with strokes marking the hollowed and bulging areas. Use the same technique to create texture as you did on the cap. Next, shade the cap along the top of the stem with a blending of Olive Green and Paynes Gray.

7. With thick white gouache, mark the areas of light and accentuate the textural depth.

8. Using a flat brush, wet the bottom of your watercolor, taking care not to go over the mushroom.

9. Fill in the background using varying shades of Perylene and Gold green.

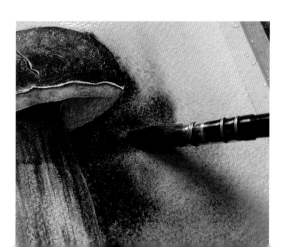

10. To create the greenery around the mushroom, use the negative effect technique (see lesson 17). Wet each clump one by one and paint the grass on the last clump.

10.

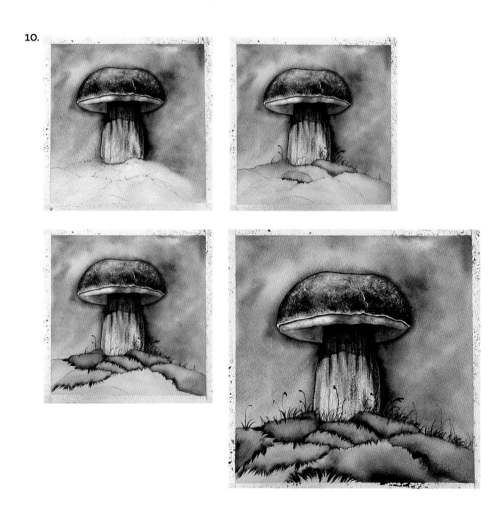

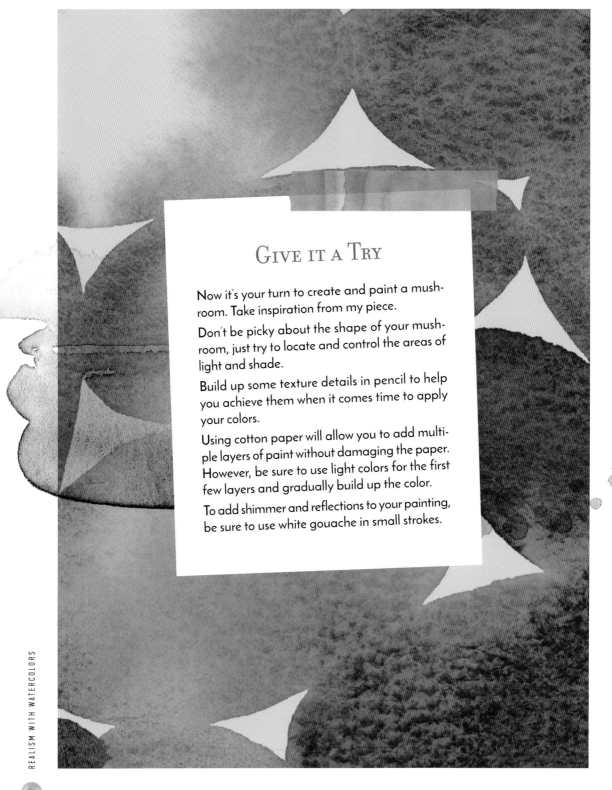

GIVE IT A TRY

Now it's your turn to create and paint a mushroom. Take inspiration from my piece.

Don't be picky about the shape of your mushroom, just try to locate and control the areas of light and shade.

Build up some texture details in pencil to help you achieve them when it comes time to apply your colors.

Using cotton paper will allow you to add multiple layers of paint without damaging the paper. However, be sure to use light colors for the first few layers and gradually build up the color.

To add shimmer and reflections to your painting, be sure to use white gouache in small strokes.

PAINTING
A BIRD

FOR THIS LAST LESSON ON REALISM, WE SWITCH TO LIVING SUBJECTS
THAT ARE RICH IN COLORS. I CHOSE TO PAINT THIS LITTLE BIRD
BECAUSE ITS COLORED PLUMAGE MUST BE DONE CAREFULLY TO
PREVENT THE COLORS FROM BLEEDING INTO EACH OTHER.

Painting animals

The difficulty encountered when painting animals often lies in building up the textures of their skin (fur, feathers, or scales, depending on the subject). When I painted my first bird in 2017, I remember that I found it really difficult to manage the right degrees of color saturation. I didn't dare to add a little black to my blends to accentuate the values and the whole thing looked bland and lacked depth.

For my next attempt, I added more saturation to the necks and ended up going overboard, so I couldn't go back to add more light or volume to the plumage. This technique of creating volume by saturating the colors in the right places is indeed the key to depicting animals more faithfully.

*The reference photo on the left
and my watercolor on the right.*

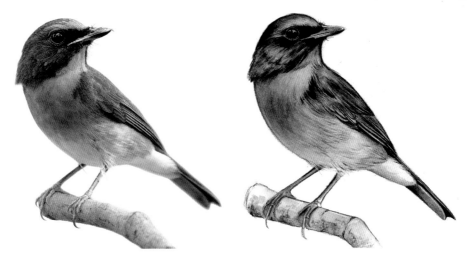

EQUIPMENT

- HB and 2B pencils

- An eraser with a very fine tip for precision in small areas and a kneaded eraser

- A sheet of Arches 300 gsm fine-grain cotton watercolor paper

- Watercolors: Paynes Gray, Ultramarine Blue, Dark English Green and Quinacridone Gold (Bréhat), Dark Burnt Orange and Yellow (Nickel Azo, Daniel Smith) and Gold Green (Winsor & Newton) for the bird. Paynes Gray, Brown and Violet (Bréhat) for the legs, and Cobalt Green (Winsor & Newton), Ocher and Neutral Ink (Bréhat) for the branch

- White gouache

- Two round brushes, one precise and one softer for diffusing the color

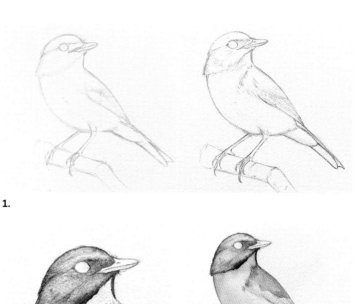

1.

2. 3.

Step-by-step

1. First, draw a sketch of your bird. Using an HB pencil, make rough shapes, then refine the lines using a 2B pencil.

2. Apply a blend of Ultramarine Blue, Paynes Gray, and English Green to the bird's head, making sure to stop when you reach the orange part of its plumage. Using a blend of Ultramarine Blue and Paynes Gray, accentuate the feathers on the outer side of the head.

3. Use this same blend on the top of the bird's wings. When the paint is dry, apply a new blend composed of orange, Quinacridone Gold, and Gold Green to the bird's belly, gradually diffusing out the color.

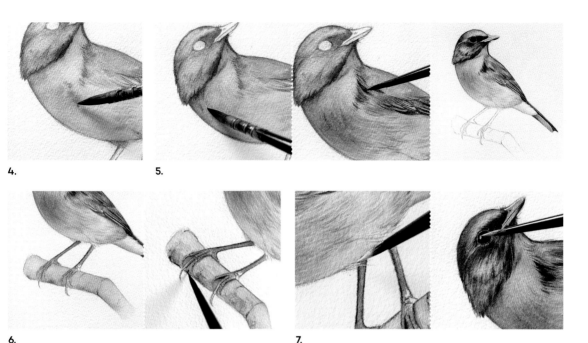

4. Apply a new layer of darker paint on the belly.

5. When the paint is completely dry, scatter small feathers on the belly and wings. Using a precise brush, add detail to the wings and apply a new layer of darker watercolor to deepen their folds. Then, fill in the eye using the neutral ink.

6. Put a blend of Paynes Gray and brown on the feet. Paint the branch using ocher and Cobalt Green. Once dry, add some neutral ink around the bird's talons to create shading.

7. To finish off, add touches of light and enhance the plumage with some white gouache.

TIP A realistic painting is best viewed from a distance so you can't see the pencil lines.

Give it a Try

Paint your own watercolor of a bird.

1. Choose this or any other model you find on the Internet with colors that inspire you.
2. Prepare the colors in your palette wells.
3. Pay attention to color variations in the plumage. Specify these variations on your sketch, if needed.
4. Use white gouache to bring out reflections of light.

CAPTURING THE BEAUTY OF NATURE

LOUISE DE MASI

Croak

Tell us a bit about yourself.

My name is Louise De Masi, and I'm an Australian professional artist specializing in watercolor painting. Before becoming an artist, I was a school teacher. Now, I've combined my love of watercolor painting with my teaching experience, and I teach watercolor classes online to students from all over the world through Skillshare and my Patreon site.

How did you get started with watercolors?

I used to work with acrylic paint, but after about 10 years, I got tired of it and was looking for something else to challenge me. So, I decided to try watercolors. The first time I tried it, I failed miserably. I put my paints away for a few years and forgot about them. I decided to give it a second try, but this time I stuck with it. I'm really glad I did. It's such a wonderful medium to use. I've been painting with it for 10 years now and it never fails to satisfy me. It has a mind of its own and often reminds me that I'm not always in charge. I'm sure I'll continue learning to use this medium for the rest of my life.

How do you find inspiration?

Watercolor is fast, fluid, and exciting. The colors illuminate the white paper and please the eye with their beauty. Watercolors can do things that no other medium can. Painting with watercolors is also always a challenge, because it can be unpredictable, but that rarely surprises me.

What is your creative process?

I usually start with a reference photo that appeals to me. I work on the subject in graphite pencil before starting to paint. This helps me to simplify the subject, develop a composition, and establish all the tonal values. I also use pencil sketches to decide what I'm going to do with all the external borders around my subject. From there, I do one or two color studies. They help me decide on the colors and techniques I'll use in my main painting. When I'm happy with my color study, I begin painting, often referring more to my studies than to my reference photo.

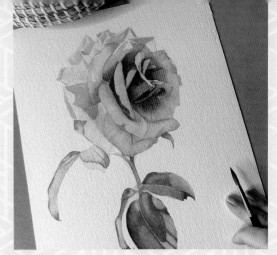

Heaven Scent

What advice would you give to help someone improve their watercolor skills?

My best advice for improving your watercolor skills is to not give up, and, most importantly, to put in the "brush mileage," as I call it. That is, paint every day if you can. Once I started painting full-time, my paintings only got better. I painted every day for a few years and my progress was incredible. When I look back at my previous paintings and see how far I've come, I see that all this practice was well worth it.

Don't compare yourself to others; compare your current work to a year ago. Everyone paints differently and everyone is at different stages on their painting journey. Don't expect overnight success. It takes a lot of work and dedication, and watercolor is a difficult medium to work with because it's so transparent. Also, don't be hard on yourself if your paintings are disappointing. I have many paintings that didn't turn out the way I wanted and I consider these failed paintings as a learning exercise.

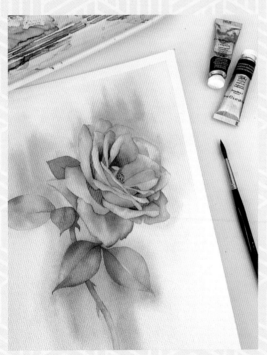

Splendid

Instagram: @louisedemasi
Website: www.louisedemasi.com
Patreon: https://www.patreon.com/louisedemasi
Skillshare: https://www.skillshare.com/user/louisedemasi

ADDING COLOR
TO A PORTRAIT

THERE ARE MANY WAYS TO ADD COLOR TO A WATERCOLOR
PORTRAIT. ONCE AGAIN, EVERY ARTIST WILL PREFER USING
SOME TECHNIQUES MORE THAN OTHERS, AND FORTUNATELY,
THIS MAKES FOR A RICH VARIETY OF ARTISTIC STYLES.

Sketches

Sketches are important for portraits because they
help guide the placement of color. I use a blending
pencil or a small brush to mark some shaded areas
so I can visualize the curves on the face better. I use
an HB pencil to draw the first lines, then with a 4B
pencil, I mark some heavier lines to make them
clearer. With a kneaded eraser, I tap the areas I want
to reduce.

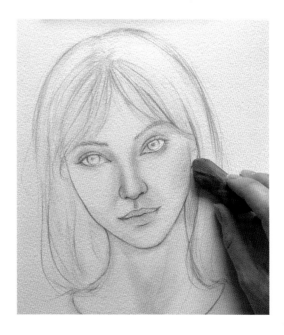

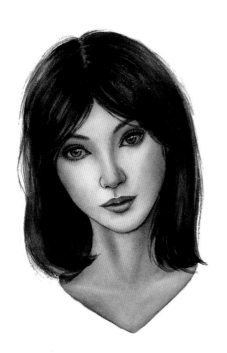

Color sequence

Since watercolor is a transparent medium, it's best
to layer a darker color on top of a lighter one, as the
reverse isn't possible, unless you use masking fluid
or take the time to properly outline each element, as
with the negative technique (see lesson 17).

I prefer not to use masking fluid on my portraits, unless my model had a flower in her brown hair, for example, and I needed to protect that area. Consequently, in painting this portrait, I'll first identify the lightest elements and start with those. Here, I would follow the following sequence:

skin → mouth → eyes → facial hair → hair

Analyzing skin color

I spend some time analyzing my model's coloring, just as I did for the mushroom piece in lesson 24. Greens, violets, reds, and yellows—the colors are many and varied, whether for light or dark skin.

I mainly use four colors to recreate skin color: ocher yellow, Dalbe red, dark ultramarine blue, and a neutral tint to achieve a darker skin tone.

By blending dark ultramarine blue and Dalbe red, I get a violet color that's ideal for the eyelids and more delicate skin areas.

By blending ocher yellow and dark ultramarine blue, I produce a green-blue that's perfect for some shaded areas or for coloring the white of the eye (which isn't really white).

By blending Dalbe red and ocher yellow, I get an orangey pink that's great for the cheekbones, nose, and mouth.

By blending the violet (from the first blend) and the orange (obtained with the Dalbe red and ocher yellow), I make a flesh color pink, ideal for the skin as a whole. I rebalance if necessary, by adding more ocher yellow.

Finally, if I want to paint darker tones, I gradually add the neutral shade to my blend to get different shades of brown.

Applying a first wash

Applying a wash involves spreading a uniform color over a large area to serve as a base for the painting. When I start a portrait, I always put a light wash over the whole area I want to paint. I wet this area first with water, using a flat brush. This will diffuse the pigments more evenly and make the drying process more uniform.

In this still wet paint, I tweak a few color variations in some areas. I then let my paint dry before applying a new layer.

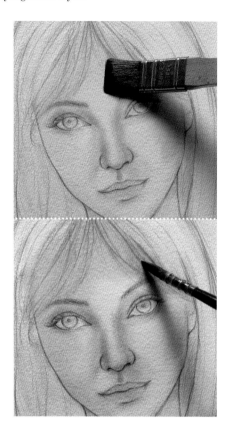

TIP Patience is a must. Between each layer, it's essential to wait for the paint to dry completely in order to avoid demarcation lines. If it seems to be taking a long time, feel free to use a hair dryer to speed up the process, taking care to remove small clumps of water on the paper with a clean brush beforehand to avoid pushing the paint to other areas. Keep the hair dryer about a foot away from the paper for even drying and be sure to monitor the paper's progress by checking for shine.

Smoothing out colors

In order to achieve smooth-looking skin, I use the wet-on-dry technique and diffuse the color to blend in with the one below.

I usually use two brushes for this. The first one, loaded with pigments, is used to apply the color on the part of the face I'm working on, while the second one, loaded only with water, allows me to diffuse the color. Using two brushes helps me avoid wasting pigment, since I don't need to rinse the brush that's loaded with color in order to blend.

Layering

As discussed in lesson 23, layering is an effective way to develop depth in our paintings. To add realism to my portraits, I always use this technique, sometimes applying up to five successive layers. That's why I always prefer cotton paper with a weight of at least 300 gsm.

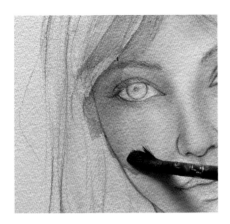

I use the same process to paint the mouth and give it volume. I add darker colors in the creases.

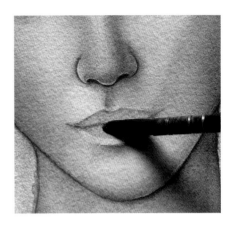

Rebalancing the shades

During the coloring process, it's sometimes necessary to rebalance the overall color scheme using a blend that may be more pink or more yellow, for example.

To do this, I apply a new wash to the area to be enhanced. This also helps blend the colors together slightly and make everything more uniform.

Eyes

I always tackle the eyes after working on the skin color because that way, I can paint the irises more easily. I start with the lightest part of the eyes, i.e., the whites of the eyes.

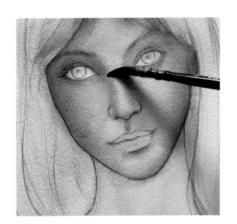

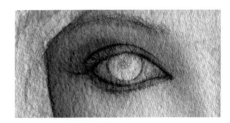

As I said before, the whites of the eyes are not completely white. Have a good look at your eyes in a mirror and you will see that the whites of your eyes have many more shades: pink, blue, green, yellow, etc.

Next, I work on the irises, taking care to add multiple color variations, then when everything is dry, I add the pupil.

Hair

The last stage of the portrait is coloring the hair. In the same way as for the face, I first apply a clear wash to the entire head of hair.

On the still wet watercolor, I apply darker shades of neutral tint, while taking care to leave white areas to add highlights and shine to the hair.

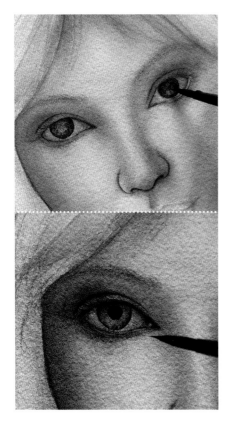

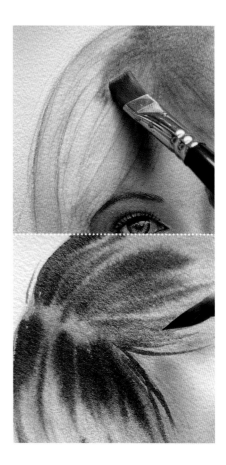

With a white pencil and a white gel pen (more intense), I add small sparkle effects to the eye. This step will make them more realistic.

Finally, I add the lashes to the upper and lower eyelids.

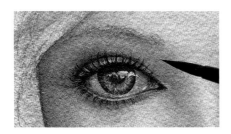

I let everything dry, then use an even more pigmented blend to darken the most shaded areas.

With this same blend, I create more contrasting highlights to add volume and texture. I take care to maintain consistent movement in relation to my sketch.

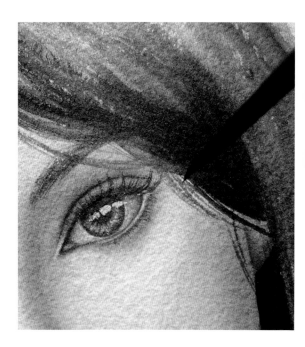

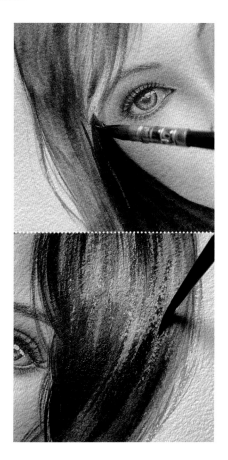

To finish, I add a few strands of messy hair to give a natural look to the movement of the hair.

Give it a Try

Dare to explore watercolor portraits by sketching a face of about 4 to 8 inches. This format will allow you to work on diffusing and details.

Practice on a sheet of cellulose paper, but keep in mind that the result will be much better when you're using cotton paper.

Your sketch doesn't have to be perfect. What's important when practicing is achieving depth by becoming familiar with blending and diffusing colors.

Before applying any color, look closely at the many color variations in a face. By doing so, you will learn to place your colors better.

DEVELOPING YOUR ARTWORK

In this last section, I'll share with you some tips that have been very useful to me in developing my artwork. I start from the principle that nothing is ever acquired and that it's necessary to practice regularly to maintain or improve your understanding of any subject. "Difficult" doesn't mean "impossible," as long as you believe in it. I've never put barriers or limits on my ambitions, but I have always fully accepted and been keenly aware of how long it would take me to achieve them. As Pierre de Coubertin used to say, "Every difficulty encountered must be an opportunity for new progress."

IMPROVING
YOUR WATERCOLOR SKILLS

TAKING ON A NEW MEDIUM CAN BE INTIMIDATING. EITHER YOU KNOW
EXACTLY WHAT TO PAINT, BUT NOT HOW, OR IT'S A LEAP OF FAITH
AND YOU JUST WANT TO BRING CREATIVITY INTO YOUR LIFE, AND
IDEALLY, YOU DISCOVER YOUR OWN STYLE. OR, YOU ALTERNATE
BETWEEN THESE TWO POSITIONS, AS WAS THE CASE FOR ME...

Setting goals for yourself

First of all, I would like to share a personal detail with you: I've never taken a drawing or painting class. I learned everything from social networks and books, along with my curiosity and perseverance. I've always been convinced that art lies dormant in each of us and that, one fine day, we decide to awaken it.

To tell you the truth, when I got back in touch with my creativity during my parental leave, I quickly felt the need to turn my passion into a job, even if I was fumbling around because I didn't know yet how to achieve this goal. I then set myself short-, medium-, and long-term personal goals, which gave me resolve and motivation in my learning.

Leitmotiv

Four words help me to improve. They represent my guidelines so I don't lose sight of the idea that nothing is achieved overnight, and that projects are only completed through hard work: **persevere, experiment, observe, and have fun.**

When I try something new, I scour the web to get a better understanding of my subject from different angles. I admit that I'm very influenced by social networks and spend a lot of time on them, but this also helps me to be aware of all the alternatives that may be available to me when I start something new.

Taking it one step at a time

In lesson 23, I talked about adapting to your level. Effectively, you have to accept that before you can achieve the big goals you've set for yourself over the long-term, you'll need to achieve small, short-term goals first, in order to keep your motivation intact.

So, if your long-term goal is to reach the moon, be aware that you'll probably have to pass through a few stars first before reaching that goal.

To paint this moon, I used the colors Moon Black by Daniel Smith and Tundra Violet by Schmincke. I drew a circle using a compass and wet the center with water. Next, I applied pigments with a granulation effect, using dabs, to create a "lunar" effect.

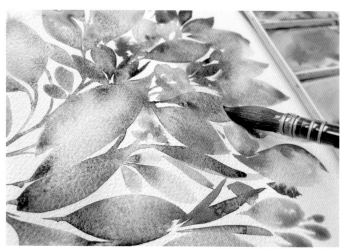

My color studies based on the greens in my palette.

Experimenting

I believe that experimenting is one of the most important ways to improve. Explore, be curious, and make artistic discoveries. You will improve much more rapidly if you carry out your own research because the process will be personal.

Additionally, if you learn something new, make sure you immediately put it into practice. Repeat the movements several times to reinforce your newfound skill.

When I'm experimenting with something new, I let go of the urge to succeed because I'm simply researching a different result than my usual one. For example, I enjoy the process of blending colors together, playing around with plenty of water, moving pigments around randomly, creating texture, trying different tools and brushes, adding salt, etc. I try to understand the limits of my medium and store up inspiration for my future paintings. are short on time. I know this well, and yet the process is so instructive that I don't ever feel it's a waste of time.

Starting over

Starting over... The enemy of people who are short on time. I know this well, and yet the process is so instructive that I don't ever feel it's a waste of time.

You can't imagine how many times I mess up my watercolors—believe me, it happens a lot. I use these times to analyze what went wrong. Why didn't it work? Were there too many elements in the composition? Were the colors not well-balanced? The list can be long. Before starting again, I envision the elements that I'll modify in the next watercolor and, through perseverance, I get a little closer each time to my goal.

My unsuccessful watercolors

During the first year of my artistic career, I was unable to throw away any of my watercolors, I told myself each time, "it might be useful." In reality, I needed it to improve and I just didn't realize it. My watercolors were a source of research that encouraged the spontaneous side of my creativity.

Lots of experiments...

Learning can be fun

It's a real philosophy. I start from the principle that it's important to have fun and enjoy what you're doing in order to improve, because things are always better when approached from this angle.

In lesson 27, I cover different ways to boost your creativity by setting yourself small personal challenges. This method can still be applied here, with a focus on improving your watercolor skills through enjoyable learning exercises.

Here's an example of a fun program you could follow:

- **Monday:** Make a galactic sky using salt.

- **Tuesday:** Work on transparency using a single color (monochrome).

- **Wednesday:** Paint a rose using two random colors.

- And so on for each day of the week.

It's up to you to be inventive and find fun subjects. Why not suggest challenges to complete together with your friends? It's always easier to stay motivated when you support one another.

These watercolors, which I thought at the time were failures, were in fact experiments. I later realized that the reason I couldn't throw them away was because they inspired me. From time to time, I would flip through all my drafts and feel the urge to pull one of them out and dare to start over.

You, too, should keep your failed watercolors at hand so you can follow through on your ideas and keep a record of your experiments. And start over quickly so you don't forget the creative process you were exploring.

GIVE IT A TRY

Try coming up with three or four words to define your artistic process and how you want to improve in this medium.

Write these words down somewhere so they become the common thread in your motivation.

Experiment as much as you can, be observant, and, above all, have fun with playful ideas that you come up with on your own or together with your friends.

MOVING
FORWARD

BASED ON MY OWN JOURNEY AND THAT OF OTHER ARTISTS, I CREATED
A TIMELINE MADE UP OF DIFFERENT STAGES ENCOUNTERED BY AN
ARTIST THROUGHOUT THEIR DEVELOPMENT. OF COURSE, THIS IS A
PERSONAL PERSPECTIVE, FOR EACH INDIVIDUAL DEVELOPS THEIR
OWN PRACTICE BASED ON THEIR DESIRES AND SITUATION.

Artistic development

Based on my experience, below is an example of a fairly typical artistic journey that might inspire you to develop your watercolor skills and set long-term goals for yourself.

Of course, it's all a question of ambition and personal motivation. Each stage can be accomplished differently and take more or less time to complete, or never be completed, depending on your aspirations. A novice artist may never go through an inspiration phase if they don't feel the need to do so and instead, start creating personal things straight away.

In the same way, an artist isn't necessarily an influencer or someone who has a community of followers.

In most cases, we don't know what our journey will look like when we're starting out. However, there's no denying the pleasure of seeing one's artwork mature and develop over time. Finding a sense of ease in your practice, and being able to create personal things that you're proud of and that others enjoy, is rewarding. So why shouldn't you imagine yourself creating beautiful, professional projects through your artistic endeavors?

Learning

This step is obviously essential. We were all beginners at one time, and we mustn't forget it. I, for one, will always remember that great feeling I got when I purchased my first watercolor palette.

LEARNING GETTING INSPIRED MASTERING INFLUENCING PASSING ON

I wanted to try everything, see everything, and paint from morning till night. I experimented for a few months with portraits, then modern floral watercolors, and then watercolor landscapes. We're never done learning.

Getting inspired

Do we really ever leave this stage? In all sincerity, I think we always keep one foot in it. It's essential because it's part of our opening up to art; to the desire to diversify our pieces and keep ourselves updated.

At the beginning of your artistic adventure, you'll certainly feel the desire and need to work on your technique by trying to copy or drawing heavily on the work of other artists for inspiration—by taking several elements from an original piece and using them to create your own, for example. It's a natural thing, it's part of the continuity of learning a new medium. However, be careful not to completely appropriate the artwork of the artists who inspire you—it doesn't become "personal" just because it came out differently under your brush, especially if you plan to publish or sell your pieces.

To ensure that you respect the work of other artists when you decide to publish your painting on social networks, you might want to ask the author of your design for permission and specify that he or she will be mentioned in the description of the image. If they're not comfortable with being copied, even if your intention isn't financially motivated, but for the purpose of learning, you must respect their choice. The relationships you develop with your peers will be all the better for it.

Mastering

You reach this stage when you become confident and start creating things from your own ideas. You fine-tune your artistic preferences and establish your style.

Influencing

Today's artists mainly exert their influence on social networks (Instagram, YouTube, etc.) and it's pretty easy to access a large amount of content. Artists' influence is an omnipresent notion these days, and it goes without saying that everyone has the potential to be an influencer and be influenced.

An influencer is someone who has built a large community of followers around their work, not just because they seem like a nice person, but because they bring a different perspective on an artistic style. They have a very personal way of approaching their medium and gradually manage to distinguish themselves from others.

The fact of exerting influence isn't something that's immediately sought by artists who are new to social networks; it's rather their interpretation of their art that naturally makes them gain visibility. See also lesson 30 where I discuss some ways to develop your visibility on Instagram using image and communication skills.

Passing on

The concept of passing on or teaching can be approached in its broadest sense. Teaching doesn't necessarily mean passing on what you know in a classroom. To me, it can also mean sharing a creative process, for free or not, during group workshops or online courses on a specific theme (learning to paint a sunset, for example).

Passing on and teaching are a way to share your understanding of your creative process with a community (beginner or not). This is sometimes even requested by the community when they want to learn more about an artist's technique.

Give it a Try

Have you ever wondered what you might do with your artwork in the short-, medium-, or long-term? Did the timeline on page 137 make you want to gain visibility or, on the contrary, did it reinforce your desire to remain low-key with your artwork?

Try to imagine different scenarios related to the development of your artistic career—what would you like it to look like?

FINDING
YOUR OWN STYLE

FINDING YOUR OWN STYLE AND CREATING YOUR OWN ARTISTIC
SIGNATURE IS THE MAIN ASPIRATION OF ANY ARTIST. IT'S IMPORTANT
TO REMEMBER HOW LONG AND DIFFICULT THIS PROCESS CAN BE,
AS IT REQUIRES EXTENSIVE RESEARCH THROUGH EXPERIMENTATION
AND RISK-TAKING. INDEED, YOU'RE NOT GOING TO WAKE UP ONE
MORNING KNOWING EXACTLY WHAT'S MISSING IN YOUR PAINTINGS.

Observe more experienced artists

An artist's style is made up of all the details that cre-
ate their signature and make their work recognizable
to others. For example, transparency is something
I've explored extensively in my compositions, so
much so that it's now an integral part of my person-
al style. I'm not the only one who uses transparency,
but I combine it with other aspects to represent my
signature, such as my color palettes, which are rather
muted and sometimes atypical, as well as my simple,
minimalist floral compositions.

One way to develop your own style is by observing
the artwork of a few artists you admire with a par-
ticular focus on trying to identify what characterizes
their art. You could, for example, consider the fol-
lowing points: is it to do with the shape of their char-
acters, their color palette, the play of light, the mood
of their paintings, or even the way they photograph
and stage their pieces? Or maybe it's all of the above?

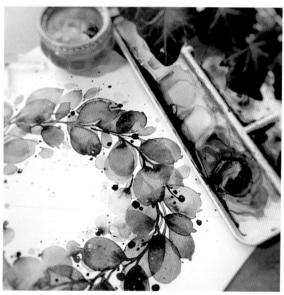

One of my watercolors shared on
Instagram.

An artist's style is established on the basis of
a rather broad set of criteria, many of which are
linked to emotions, to each person's perception,
and to a general feeling that one experiences when
looking at their artwork.

The funnel

I see the quest for an artistic style as a funnel: through extensive experimentation, you gradually fine-tune your tastes and inspiration in a much more precise way, until characteristic elements in your paintings become apparent.

In my humble opinion, we're not actually seeking the style, but rather it's the style that seeks us out as we develop our skills.

Fine-tuning your tastes

Realism, abstraction, modern watercolor… Which artistic movements are you most responsive to? To figure this out, you need to look at a lot of different interpretations and get a sense of the many possibilities this medium has to offer, in order to find what resonates with you. Dare to try! Try a variety of styles so you can say, "I know, I've tried it and I'm sure this style of painting isn't me," or, on the other hand, "it's right for me!"

It may seem complicated to tackle multiple art movements, but it's the best way to get to know what you like. Those tastes that change and evolve according to moods and experiences…what you didn't like yesterday might be what you prefer tomorrow. Personally, I started painting watercolors by painting realistic portraits and was convinced that this was the only thing I was drawn to. Then one day, I decided to explore the other possibilities that my medium offered me, and I don't regret it! Getting out of your comfort zone is risky, because there's that fear of failure and disappointment, but sometimes we then realize that the things we know about are really just a drop in the ocean of possibilities that are out there.

Discovering your style

This is a very long stage, because it involves regular practice, focusing on a specific subject to be worked on over several days or months of exercises, experimentation, personal challenges, failures, successes, doubts, and perseverance. In this way, you'll build up a large number of paintings that you can compare in order to analyze your development, identifying the ideas that come up often, the recurring color choices, what you enjoyed doing, and what you didn't. You may feel the need to explore a particular aspect further to get to the heart of a form of expression that you like. It's through persevering with this research that, little by little, your personal style will emerge.

I frequently use my Instagram gallery to analyze my work over the course of several days or even months.

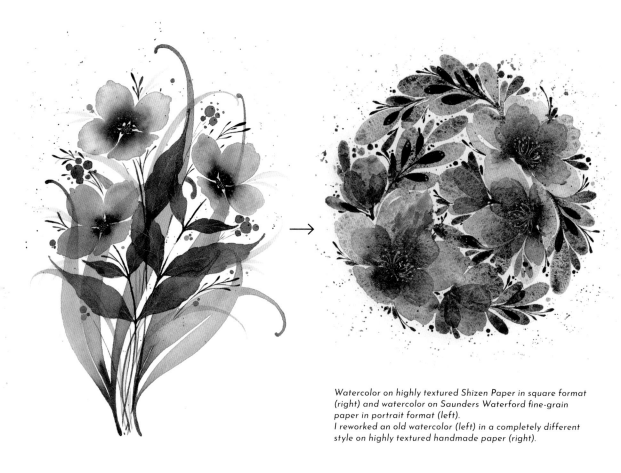

Watercolor on highly textured Shizen Paper in square format (right) and watercolor on Saunders Waterford fine-grain paper in portrait format (left).
I reworked an old watercolor (left) in a completely different style on highly textured handmade paper (right).

I like looking at how the flow of my artistic signature is evolving (colors, shapes, photos, etc.), often changing according to my moods, but also influenced by the equipment I use.

Looking back can also be beneficial, returning to some of your old pieces and exploring them with a different style and using different equipment and tools. This helps update our ideas while maintaining a familiar context that we like.

GIVE IT A TRY

What does the phrase "having your own style" mean to you? How do you feel when exploring the artwork of artists whose style you instantly recognize?

Take a look at the Instagram accounts of the artists I interviewed for this book: @magrish, @mirglis, @louisedemasi, @stephanieryan, @sylvanclayworks, and @LescouleursVF.

You'll notice that the mood permeating each of these accounts is immediately recognizable.

Next, analyze your own work to try to identify characteristic elements that might indicate your style.

SHARING
ON INSTAGRAM

ARE YOU A NOVICE PAINTER WHO'D LOVE TO PUBLISH YOUR PIECES ON SOCIAL NETWORKS, BUT YOU'RE A BIT AFRAID OF OTHER PEOPLE'S OPINIONS? BE ASSURED THAT YOU'RE NOT THE ONLY ONE! I ALSO FELT THIS FEAR AND DOUBTED MY ART.

The power of Instagram

Instagram is a network of thousands of artists of all levels in which comparing yourself to others is a fairly natural tendency, but one that may be detrimental to your creativity. However, there's no better way to improve than to learn from the best artists. Through their posts, they show us what's possible if we work hard and persevere. They allow us to explore their rich and creative universe and sometimes even invite us to join them by sharing tips on their methods via the platform's various features (IGTV, stories, live, etc.).

The seven years that I've been on Instagram have been a reflection of my process of learning and researching my artwork and style. I have explored many different accounts and discovered different artistic signatures and techniques, from traditional drawing to digital painting, via so many other different styles.

Today, Instagram is like a huge art gallery where you can interact with artists from all over the world, and the benefits far outweigh the drawbacks.

Preconceived ideas

I've read and heard a lot about social networks.

- They isolate us.

- There's too much nonsense.

- There's too much plagiarism.

- There's too much criticism.

Personally, since I've been sharing my artwork on social media, I've talked to more people than ever before. Sure, being able to interact and rub shoulders physically with artists is very rewarding, but would I have had the opportunity to do so with so many artists from around the world without Instagram?

The network has opened up many opportunities for me; the most important of which has been sharing. Yet, it wasn't something I expected when I published my first watercolor in early 2018, as a response to a challenge that Marie Boudon suggested when she brought out her first book Fleurs à l'aquarelle (Watercolor Flowers). I felt such intense energy that I couldn't really describe it in words.

Over time, Instagram has also allowed me to form some great partnerships with fine art brands, particularly with Dalbe.

Finally, sharing your pieces on Instagram will allow you to keep track of how your artwork evolves over time. I find it fascinating to take stock of my creative year and see how far I've come.

Getting started on Instagram

Are you a new artist on the platform and not sure where to start in terms of joining a community of artists, getting noticed, making your mark, and learning some essential etiquette? Here are some tips to help you get a head start.

Keywords

Before you post your first image, I recommend you familiarize yourself with the application's various tools.

- **Feed:** Represented by the icon in the shape of a house, this is where the images posted by the accounts you've subscribed to are displayed.

- **Followers:** Refers to the people who follow your Instagram account. This information is located at the top of your profile, between your number of posts and the number of people you're following.

- **Hashtag:** #watercolor, #flowers, #landscape— these are some examples of keywords that you can put in your post descriptions so your images appear if these words are searched by users. For example, your pieces with the hashtag #watercolor will be displayed for everyone who searches for it.

- **Like:** Liking a post using the heart icon that appears under each post.

- **Live:** To record and broadcast a live video, visible only to your followers.

- **Stories:** Temporary videos or photos that are displayed directly above your profile.

- **Story Highlights:** Giving permanent visibility to some stories.

- **Reels:** Videos of less than 1 minute. A tab allows you to view them in the same way as your news feed.

- **Tag:** Mentioning another user's account in a comment or post. Usually, this person receives a notification.

- **Private Messages:** To interact with other users by clicking on the small plane icon.

The list of application features is much longer, but these are the most useful to start with.

The algorithm

Since Instagram often tweaks its algorithm and I'm not an expert in this field, I'll just give you the basics of how it works.

An algorithm aims to analyze the interaction that your posts generate during their first few minutes. The buzz that a post generates, measured in a broad way through likes, shares, saves, comments, generated screenshots, etc., will improve your visibility in your followers' news feeds, but also to other users.

If I have one piece of advice it's not to pay too much attention to this data and to always keep your distance, in order to avoid falling into the hellish spiral of chasing likes. Indeed, putting pressure on yourself to get as many as possible can have the opposite effect and be detrimental to your creativity.

Posting a photo

Many of the artists whose accounts I follow have one thing in common: their gallery is visually stunning, and a beautiful balance is achieved through careful color combinations and staging. Within just a few seconds, we understand these artists' signatures.

When I shared my first drawings in 2017, I wasn't at all into embellishing my images, as it seemed too complicated and I wasn't sure how to do it. Little by little, I became aware that these efforts have a real impact on an artist's visibility on social networks.

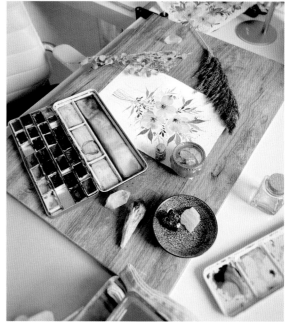

Try arranging elements around your watercolors and look for good natural light coming from the front and not from above to avoid reflections. Make choices. For example, I don't mind the shadows cast by my decorative elements, as I find that they bring the whole picture to life.

In order to show off my personality and signature through my photos, I improved my visuals by accentuating them with small elements (foliage, stones, equipment, photo background), and perfected my photography skills by paying attention to framing and capturing good light. With practice, you'll soon be able to stage your watercolors and create a mood. It has become something I really enjoy doing. When I walk in the countryside, I always keep an eye out for little treasures to decorate my pieces.

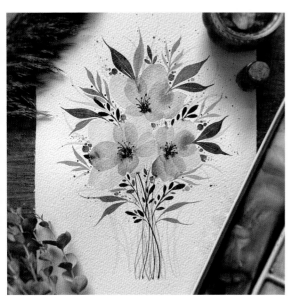

Here is the resulting shot I took of my staging. I touched up some contrasts and focus effects to highlight my watercolor.

I like to reflect nature in my photographs. My staging tends to be forest related, so I collect a wide range of foliage.

The mood you create through your photos will gradually identify you to your followers, so that they will recognize your style as soon as they see one of your photos in their news feed. This sense of familiarity is sure to generate interaction. In addition, you'll also find it easier to reach a wider audience with your content. Finally—and this is a key point for me—don't you think that the best way of honoring your work is by presenting it beautifully?

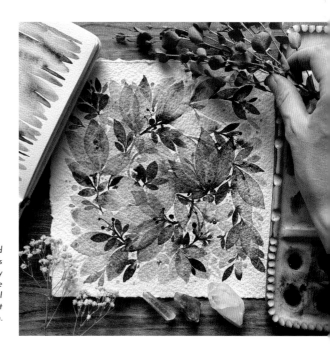

Here I focused on echoes of color in the items around my watercolor: on a small notebook and in Sarah Diane's ceramic palette, you can see the blends I used in my painting. In the areas that seemed a bit empty, some foliage and crystals are reminiscent of my signature. I shot it close enough that the elements around it did not overpower my illustration.

Increasing your visibility

Being able to interact with a community of artists who share the same passion is really the greatest benefit of this network. Don't be afraid to interact with your peers by sharing their content in your stories from time to time. Leave a friendly comment, participate in the challenges without necessarily completing them, etc. This will make it easier for you to connect with other artists and get to know them better. Feel free to ask questions, take an interest in others, and read the captions on the posts.

At the same time, try to post two or three times a week, at times when your followers are most likely to be active on the network, to show that you're active, too. Use relevant hashtags in your post descriptions. And why not try posting some video content showing your creative process using the Reels tool? This will allow you to vary the content in your gallery, between photos and videos.

GIVE IT A TRY

With the goal of improving and exchanging and sharing with other artists, create an Instagram account specifically for your artistic pursuits, if you haven't already done so.

Familiarize yourself with the application's various features. Use the search feature to look for some hashtags: #watercolor, #painting, #daretowatercolor, for example. You can also visit my profile: @jenny_illustrations, and say hello—I'll be really pleased to hear from you!

Before posting a photo, make sure you prepare it in a way that highlights your artwork. Use hashtags that are relevant to your post.

Share some details about yourself, perhaps in the description of your post, because it's always nice to know a little more about the people behind a profile.

BEATING
THE INSPIRATION GAP

IN THIS LESSON, I'LL SHARE MY PERSONAL THOUGHTS ON THE FAMOUS "INSPIRATION GAP" THAT SO MANY OF US EXPERIENCE, AND WHY YOU'LL OFTEN ENCOUNTER IT YOURSELF ALONG YOUR JOURNEY.

Prevalence of the inspiration gap

Going back to my artist's progression timeline (see page 137), I would say that the inspiration gap is much more frequent when you reach the middle stages, i.e., when you start to create your own kind of art. You no longer wish to copy the artwork of others, but to differentiate yourself from them. It's most often during this search for an identity that you'll encounter a lack of inspiration.

For me, I'd say I experience a slump at least six times a year, if not more. I get this feeling of not keeping myself updated, of constantly messing up what I'm doing, and feeling reluctant to post my watercolors online. In short, it's a painful feeling of self-doubt. But why so often, you may ask? Is it an indication of something negative?

The reasons

Several factors combine to explain the onset of this feeling. The first is that I produce a lot of watercolors. I try to do at least three a week. This means that I have to keep updating my work, which requires a huge time commitment and a lot of artistic karma to keep up. Indeed, the art I produce requires research to remain varied. For example, when I was doing portraits in 2017, I had less problems with this because my paintings took me longer to complete and my models were easier to find.

I'll be honest with you; nowadays, I produce a lot of watercolors in order to stay active on my social networks because I need to keep a high profile for my work. This generates a certain unconscious pressure that I impose on myself. When I'm inspired and have tons of ideas, it can be very positive, but when inspiration is lacking, I start to doubt my ability to keep up the pace without compromising the quality of my work.

How can we overcome it?

First of all, I think we have to find the source of our lack of inspiration. Depending on your circumstances, you may find the solution at the heart of the problem. If it's due to a lack of time, as it is for many people, perhaps try to set aside a specific time for your activities by reorganizing your daily tasks. For me personally, my inspiration gaps are often linked to a lack of ideas.

Challenging yourself

When I create a watercolor that I love, I say to myself "this medium has infinite resources, I'll never run out of inspiration!" When I get very self-critical—when I compare myself to others or force myself to be as diverse as possible in the content I share on Instagram to generate interest—I challenge myself with the following questions: would redoing one of my watercolors from a different angle be frowned upon? Do I need to prove anything to enjoy my art? Does the perfect composition really exist?

Art is a question of perspective—it's seen differently depending on one's viewpoint. Whether you paint a bouquet with a thousand colors or just one, each person will feel differently about it. It's a matter of taste and you can't please everyone, so the priority is pleasing yourself.

The first thing I work on is accepting that I can create simple things when I need to and trying to have fun doing it.

Let go

When I have overcome my moments of doubt, which are often at the heart of my blockage, I try to start from scratch.

I take a sheet of watercolor paper, either a fresh one or the back of a failed watercolor, and begin studies of shapes combined with colors. I don't do it in my notebooks because I need a large enough surface area for clearing my blockages. I paint shapes, look for colors without a purpose, and simply play around with my palette. I make blobs, circles, whatchamacallits—until it attracts ideas and releases my tension.

By painting without questioning, I realize that I'm painting the shapes that make me happy and the colors that I want. If I repeat this exercise a week later, the result will be completely different because I won't be in the same emotional state.

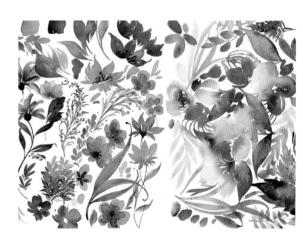

Sometimes, I let myself be guided by shapes and color palettes that I find in my books, then continue to explore. On the other hand, I also surround myself with my own favorite watercolors, which comfort me and give me confidence in myself.

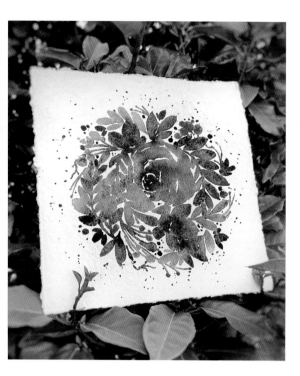

When I've finished experimenting, I feel a pleasant sense of letting go—there are no more constraints or controls. These pages are where I have made the most progress, as they have opened me up to ideas, as well as allowing me to vent my stress and frustration.

Everyone has their own technique

Each artist has their own tricks for overcoming a lack of inspiration, depending on their personal situation. My friend Blanche (@leaubleue_ on Instagram), who has a background in design, explained to me that her technique for dealing with periods of inspiration gap is to regularly give herself small projects and artistic challenges to continually stimulate her creativity. This way, she never runs out of ideas and is less likely to experience a slump.

She also told me her favorite tip, which is to create research boards (also called mood boards) from collections of images taken from her books or the Internet, which help guide her when she starts a new project.

Other artists feel the need to get away from it all, or even to change the medium, in order to start again with new ideas. Some also like to change something in their creative habits. For example, changing the size of watercolor paper, brushes, using atypical color palettes, etc.

Taking part in Instagram challenges

Taking part in challenges set by other artists on Instagram is a great way to boost your creativity. In fact, that's how my watercolor adventure began in early 2018, through a challenge set by Marie Boudon (@ tribulationsdemarie). It's also a great opportunity to get to know other artists and encourage one another.

If there isn't a challenge going on when you run out of inspiration, why not take inspiration from previous ones and create your own personal challenge?

Additionally, seasons and periodic events are a good springboard for finding inspiring motifs and color palettes.

GIVE IT A TRY

To prepare for this famous inspiration gap, I recommend that you try out the different methods mentioned above.

- At the same time, try to identify possible causes for your inspiration gaps. From time to time, when you feel the need, try the letting go exercise on the back of a watercolor you're not happy with.

- Paint without any preparation, just make shapes and play with colors. Look at beautiful pictures of plants in your books or on Pinterest, for example, and soak up the mood without trying to copy it all.

- Vary your mediums in order to diversify your methods and the outcome of your pieces.

- Follow challenges on Instagram or create your own short-term challenge around a theme that inspires you: fall, leaves, blending, transparency, etc.

- If another medium appeals to you, use this time to try it out as well, then when you feel ready, return to watercolors with new ideas.

REFLECTING ON
YOUR PROGRESS

OVER THE COURSE OF YOUR LEARNING, HAVE YOU TAKEN THE TIME TO REFLECT
ON YOUR PROGRESS? WITH OUR NOSES BURIED IN OUR PAINTINGS, WE
SOMETIMES DON'T HAVE THE TIME TO STEP BACK. HOWEVER, I BELIEVE THAT
THIS SELF-EXAMINATION IS IMPORTANT IN ORDER TO CONTINUE TO IMPROVE.

Analyzing past watercolors

Depending on the pace at which you paint, I recommend doing this exercise of comparing and analyzing your work every six months or so, or even once a year, either via your Instagram gallery or by physically pulling out your paintings. That is, of course, if you have made sure to keep your very first watercolors.

Sometimes the progress will seem great, while at other times you will feel like you're stagnating, or even regressing, but I assure you, this feeling is normal and will return throughout your artistic journey. It may follow an inspiration gap, as seen in lesson 31.

If you're having trouble analyzing your own pieces and identifying areas where you could potentially improve and continue moving forward, seek some external advice. Try showing your artwork to people you know or people who practice a similar art to yours so you can get an objective view. Sharing your doubts is a difficult exercise, but one that often proves beneficial in enabling you to move forward.

Accept criticism

This isn't an easy exercise, but remember that criticism, when it's constructive and objective, is very instructive. I remember, for example, my "portrait" period (all mediums combined), during which I was absolutely incapable of taking an objective look at my work because it absorbed me so much that I lost all perspective. So, I asked my husband to give his opinion.

At first, I was frustrated with his criticism because after hours of work I just wanted to hear, "It's amazing!" Yet, I also knew that his honesty was what would move me forward. I began looking at the work of artists I admired and analyzing what I could do better. I took notes, watched tutorials, and then applied my new knowledge. The result was far from perfect at the beginning, but with perseverance, I progressed.

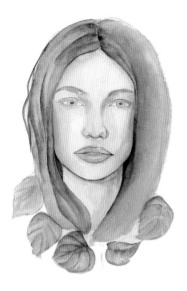
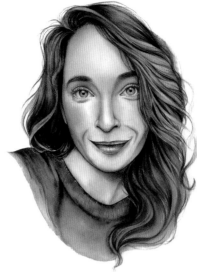

On the left, my very first watercolor portrait, which I didn't have the courage to finish. On the right, one of my self-portraits, one year later.

To conclude, I'd like to reassure you about my progress, which may seem fast to you. Being on parental leave at the time, I was able to work extensively on my technique and thus progress rapidly.

However, I know that we often lack the time to learn a new medium. Go at your own pace; once again, the important thing is to enjoy your artistic endeavors and not feel pressured.

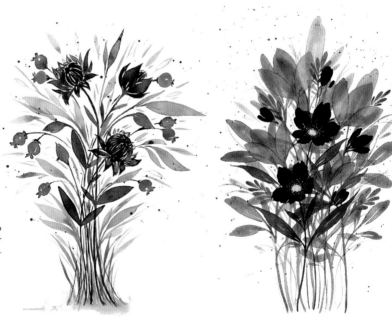

Comparison between two floral compositions one year apart.

GIVE IT A TRY

Wait six months or more, depending on the pace at which you paint, and analyze how your work is progressing, having kept it for this purpose.

Try to see how your movements, color choices, etc., are improving. In addition, it's sometimes good to have one or more external opinions to help you pinpoint any blockages.

Criticism, if it's constructive, is an excellent way to progress.

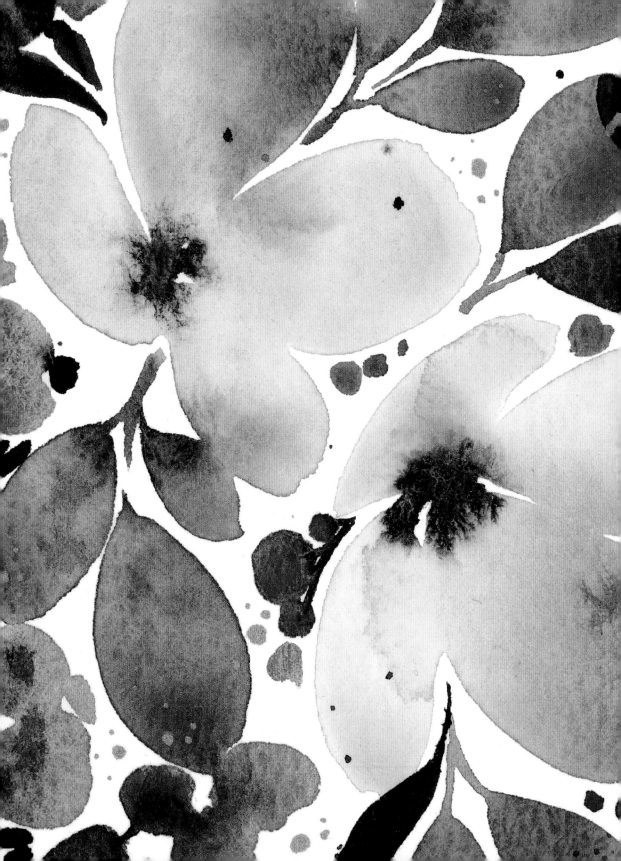

CONCLUSION

I hope you've enjoyed working through these 32 lessons with me. In them, I've shared my creative process with you and offered tips on how to persevere in the face of any obstacles you may encounter in your artistic endeavors.

Keep in mind that watercolors can be used in many different ways and that there are no limits to your creativity.

There's no magic formula for gaining fluency and confidence in this medium quickly; simply practice regularly and apply what you've just learned. Go easy on yourself and take it step by step, one challenge at a time. We were all beginners at one time and had to pass through the same stages to get to our goal!

ACKNOWLEDGMENTS

First of all, I would like to thank my editor, Nathalie Tournillon, and Éditions Eyrolles for the trust they have placed in me in writing this book.

To my dear husband for his confidence, honesty and keen eye that have helped me improve my techniques and achieve my dreams.

To my two daughters, Lea and Wendy, who are my greatest sources of energy in every project I undertake.

To my partner, Dalbe, for the cooperation that is so important to me.

To my dear fellow artists, Sarah Diane, Sarah Van der Linden, Valentine and Florence, Maria Smirnova, Louise De Masi and Stephanie Ryan, for taking the time to share a little of their lives with us.

To my friends—Emma, Marie, Salomé, Anne-Claire, Florence, Valentine, Gaëtane, Chloé, the two Julies, Sarah, Cathy, Marlène, Blanche, Caroline, Sofia, Camille, Emmanuelle, Gladys, Valérie and many others—who have always been there to answer my questions, give me a boost and support me when I needed it.

To all the inspiring artists who made me want to get started and persevere, and to those who take the time to share and pass on their precious expertise.

About the Author

I reconnected with my creative side during my parental leave in 2016, drawn to the beautiful illustrations I was discovering on social media.

I then decided to create an Instagram account dedicated to my artwork. Since I hadn't been to art school, I relied on tutorials found on YouTube and the Internet. I started out doing portraits using alcohol markers, then graphite pencils, but something was missing...

At the end of 2016, I bought an iPad Pro in order to explore digital painting and do caricature portraits, but I soon felt like I wasn't keeping myself updated.

I discovered the delicacy of watercolors in late 2017 and quickly realized this medium's creative potential. I was more determined than ever to progress quickly. Then, in early 2018, I discovered the work of Marie Boudon, who introduced me to modern floral watercolors.

Since then, I have not stopped painting—for myself, for others, and as a job. I paint portraits, landscapes, flowers, and abstracts. I'm never bored because I learn something new every day and I make sure to diversify my art to keep my creativity updated.

Within the creative community that I've been a part of since 2018, I've discovered sharing, caring, challenges, and perseverance, all of which keep bringing us together and uniting us, even though we're far apart.

Website: www.Jennyillustration.fr
Instagram: @jenny_illustrations
YouTube: Jenny Illustrations
Facebook: Jenny illustrations

INDEX